IMAGES
of America

NORTHWEST
BRONX

Bronck's Noo POHS

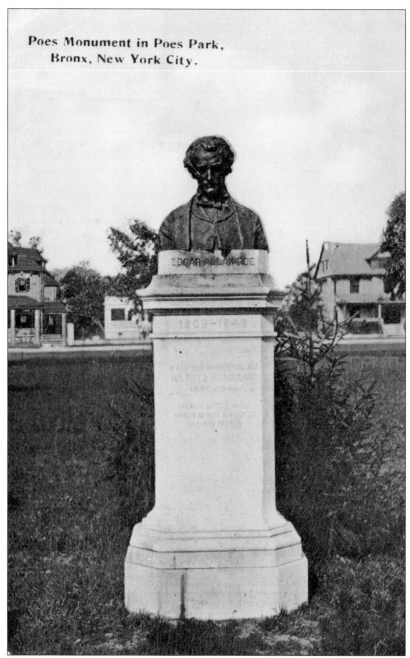

Poes Monument in Poes Park,
Bronx, New York City.

Edgar Allan Poe made Fordham his last home from 1846 to 1849. The Bronx Society of Arts and Sciences dedicated this bronze bust at Poe Park on the 100th anniversary of the birth of Edgar Allan Poe on January 19, 1909. This postcard view was taken from Kingsbridge Road looking toward the Grand Concourse. The bust by sculptor Edmund T. Quinn is now housed inside Poe Cottage. (Authors' collection.)

ON THE COVER: This photograph of Havender's Monumental Works was taken around 1903 at their plant located at 3686 Jerome Avenue, across the street from Woodlawn Cemetery. (Courtesy of the John McNamara collection.)

IMAGES
of America

NORTHWEST
BRONX

Bill Twomey and Thomas X. Casey

ARCADIA
PUBLISHING

Published by Arcadia Publishing
Charleston, South Carolina

Printed in the United States of America

Library of Congress Control Number: 2010937385

For all general information, please contact Arcadia Publishing:
Telephone 843-853-2070
Fax 843-853-0044
E-mail sales@arcadiapublishing.com
For customer service and orders:
Toll-Free 1-888-313-2665

Visit us on the Internet at www.arcadiapublishing.com

Northwest Bronx is dedicated to East Bronx History Forum and
Bronx River Alliance members, some of whom were photographed
in 2010 at the water tunnel worker's memorial in Woodlawn.

CONTENTS

ACKNOWLEDGMENTS

Unless otherwise noted, all of the images in *Northwest Bronx* come from Thomas X. Casey and Bill Twomey's personal collections, however, there are a number of friends whose contributions to the work merit a great deal of gratitude. Bill Armstrong was especially helpful with respect to some transportation photographs, as his knowledge of streetcars cannot be duplicated. Sharon Casey and Carol Twomey have expressed a great deal of patience, as their husbands often disappeared for hours on end to explore some long-forgotten building or park that was being considered for inclusion in this work. The authors have also freely utilized some classic photographs from the John McNamara collection. There are others to be thanked, including John Collazzi and the *Bronx Times Reporter,* Nick DiBrino, Robert Stonehill, the late Lou Testa, and the late Ronald Schliessman. A special thanks is also extended to Erin Vosgien of Arcadia Publishing for literally coaxing this book out of us.

INTRODUCTION

The Northwest Bronx is herein defined as that area of the borough situated north of Fordham Road and west of the Bronx River. The communities of Spuyten Duyvil, Kingsbridge, and Riverdale are also included and offer some of the most spectacular views of the Hudson River and the Palisades. It is here that Wave Hill with its beautiful formal gardens can be found. Once home to such luminaries as Teddy Roosevelt, Mark Twain, and Arturo Toscanini, the 28-acre estate is now a beautiful nature preserve. John F. Kennedy's boyhood home still stands not far from Wave Hill. Further north in Riverdale, abutting the Yonkers border, is the Fonthill Castle, built in the early 1850s by the wealthy actor Edwin Forrest. It has been home to the College of Mount St. Vincent since 1856.

The Bronx, indeed, has been dubbed the Borough of Universities for the many institutions of higher learning found therein. Some others covered in this modest work are Manhattan College and Fordham University. Lehman College is the former Hunter College facility that served as the U.S. Naval training school for Women Accepted for Volunteer Emergency Service (WAVES) during World War II. The New York Botanical Garden has also served in the advancement of education through their worldwide research for new medicines, using plants to cure diseases. On the east bank of the Bronx River is the Lorillard Snuff Mill, a National Historic Landmark. The hemlock forest and acre of roses are other attractions, while the Enid Haupt Conservatory attracts visitors from throughout the world.

This book, however, is more than a story of institutions and estates—it is also a story in pictures of the people who created the communities of the Northwest Bronx and called them home. While Yiddish used to be heard along the Grand Concourse, an assemblage of brogues from the four provinces of the Emerald Isle can still be heard in the community of Woodlawn. Irish native products can also be found in the stores of Woodlawn, where Irish newspapers still far outsell the *New York Times*. Woodlawn Cemetery, directly south of this community, was established in 1865 and holds the remains of some of America's brightest and most talented personalities, such as Duke Ellington, W.C. Handy, Nellie Bly, Herman Melville, George M. Cohan, Bat Masterson, Augustus D. Julliard, and Fiorello LaGuardia. Others include captains of industry, such as Collis P. Huntington, F.W. Woolworth, R.H. Macy, J.C. Penney, and Jay Gould. A free George M. Cohan concert is held each Fourth of July, and guided theme tours are offered throughout the year. The cemetery is also a valuable historical and genealogical resource, and their records have solved numerous enigmas to researchers throughout the years.

Abutting Woodlawn to the west is Van Cortlandt Park, a hub of activity and centerpiece of the northwest Bronx around which much of its cultural life revolves. The park was the site of more than one Revolutionary War battle, and Chief Ninham and 17 of his warriors died there in 1778 while fighting for American independence. A stone cairn with a bronze memorial plaque marks the site of the Stockbridge Indian martyrdom. The park is also home to the oldest public golf course in America. The Van Cortlandt mansion is the oldest building in the Bronx, and

Gen. George Washington did actually sleep there. The museum is well worth a visit. A window from the sugar house in lower Manhattan, where many American patriots were jailed and died at the hands of their cruel captors, was preserved and is on display in the rear of the mansion. The park also saw use as a military parade ground and a polo field among other uses. Today outdoor concerts and games are held there, while the trails are used by track clubs and nature lovers. Others come to the park to go horseback riding, kite flying, and enjoy other outdoor pastimes. This is a multiuse park of 1,146 acres.

The communities that comprise the Northwest Bronx have always been diverse, accommodating émigrés from Germany, Italy, Ireland, Albania, and many other areas, including Asia, Africa, Latin America, and the Caribbean. Their stories are our stories. Traveling from the community of Fordham through Bedford Park and Norwood to Van Cortlandt Park at the north, a marvelous kaleidoscope of community life is brought together on these pages. Education, business, prayer, and play all have their places in the life of the Northwest Bronx and can be found on the pages of this work.

One

FORDHAM

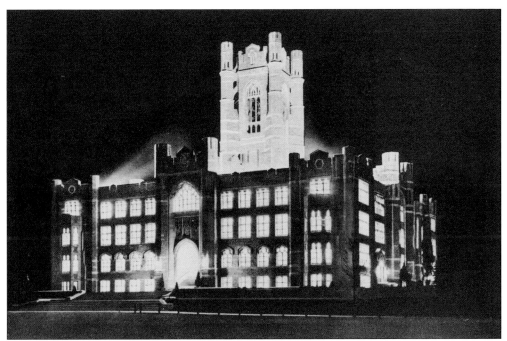

Built in 1936, Keating Hall is situated in the center of the Bronx campus of Fordham University, facing west onto the Edwards Parade Ground. The new football field would be to the left. The hall was named for Joseph Keating, SJ, a Jesuit priest, Fordham treasurer (1910–1948), and professor of finance. Classes, the media center, and radio station WFUV are located here.

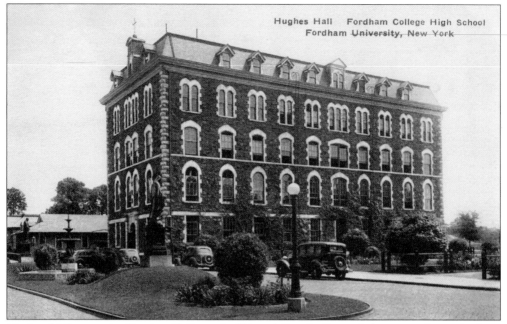

Hughes Hall, opposite Keating Hall on the Edward Parade Ground, faces east. It was built in 1891 and named for Fordham University founder, New York archbishop John Hughes (1797–1864). This 1942 postcard was sent to Springfield, Massachusetts, from a woman named Alice and reads, "Saw Father Rooney today." Hughes Hall is now a coeducational residence segregated by floor and houses about 250 students.

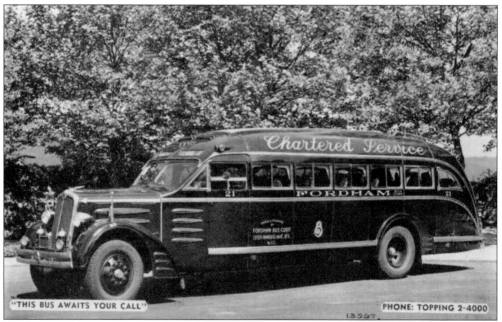

One of the first gas-powered bus routes in New York City was at City Island in the Bronx. This late 1940 bus was from the Chartered Services of the Fordham Bus Company, located at 1350 Inwood Avenue west of Jerome Avenue at 170th Street. This view appears to be in Riverdale with the New Jersey Palisades in the background.

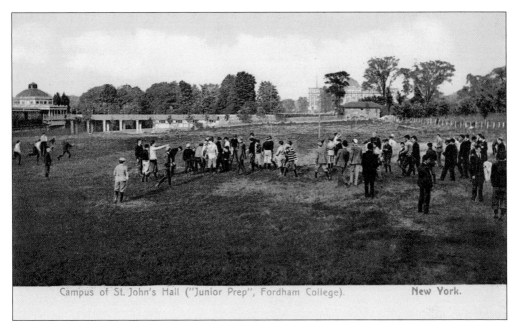

Campus of St. John's Hall ("Junior Prep", Fordham College). New York.

This c. 1906 postcard depicts a high school football game of the "Junior Prep," now "Fordham Prep." Fordham University football became famous with their "Four Blocks of Granite" that included Vince Lombardi on the team. The Botanical Garden museum building is viewed to the north and the Third Avenue El Botanical Garden Station is visible on far left.

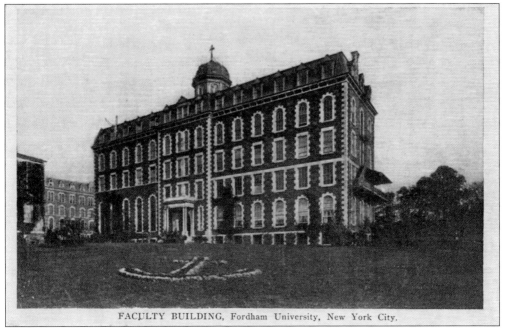

FACULTY BUILDING, Fordham University, New York City.

This 1919 view of the 1867 faculty building, called Dealy Hall, was sent to Davis, New Jersey. It reads, "It is pretty here and the food is very good." A Mr. Munson, the sender, also indicated that his room was on the top floor. Dealy Hall is located opposite Keating Hall and faces west, with the rear toward the Edwards Parade Ground. Dealy Hall is named for Patrick F. Dealy, SJ, the Fordham University president from 1882 to 1885. The former residence is now used as offices and for classes.

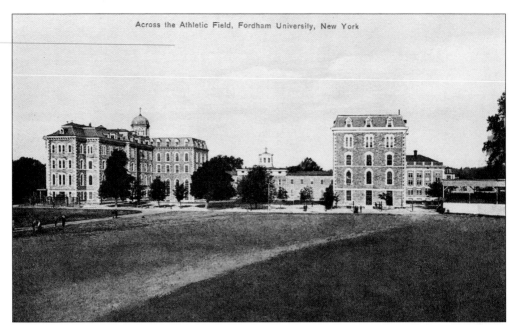

Fordham College was opened on June 24, 1841, and was incorporated as St. John's College on April 10, 1846, at which time it became a university. Archbishop John Hughes, the founder, placed it under the care of the Society of Jesus (Jesuits) the following year. The Rose Hill campus is located at Fordham Road, and the name of the school was officially changed to Fordham University in 1907.

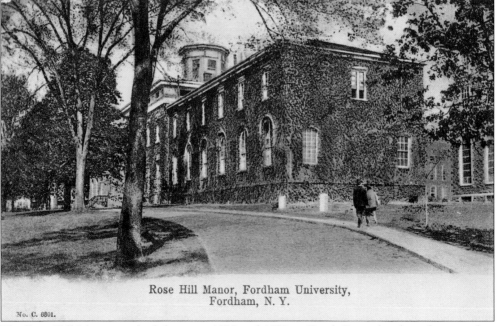

Rose Hill Manor, Fordham University,
Fordham, N. Y.

No. C. 6801.

The Rose Hill Manor was built between 1836 and 1838 in Greek Revival style and acquired in 1839 by Right Rev. John Hughes. The manor house is now the Fordham University Administration Building, facing west toward Webster Avenue. The Collins Hall and the statue of Archbishop Hughes are out of view to the left. The ivy no longer covers the building.

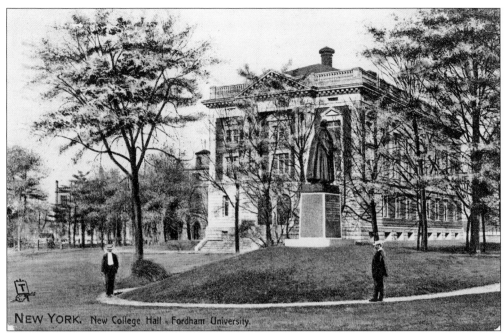

NEW YORK. New College Hall - Fordham University.

Pictured in 1908, the "new" College Hall, built in 1904, is facing south toward Fordham Road and is a four-story structure 140 feet long and 69 feet wide. It contains eight classrooms and an auditorium with a seating capacity of 1,000. The university chapel is viewed at the left of the hall. The statue of Archbishop John Hughes is on the front lawn. The hall was named Collins Hall in 1905 for university president John J. Collins, SJ (1904–1906).

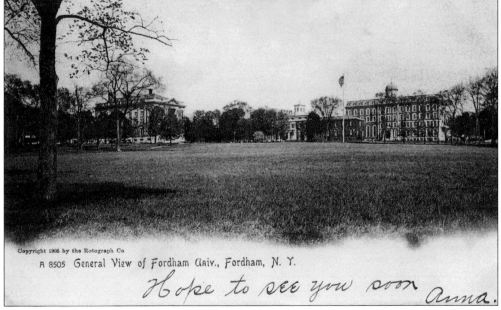

Copyright 1906 by the Rotograph Co

A 8505 General View of Fordham Univ., Fordham, N. Y.

Hope to see you soon Anna.

This 1906 view of Fordham University is looking from the west on Webster Avenue. Collins Hall is on the left and Dealy Hall is to the right, with the Rose Hill administration building in the center. Three dorms for 500 coeducational students were added to the left of Collins Hall in 1951 and were named for three Jesuit martyrs and saints—Jogues, La Lande, and Goupil.

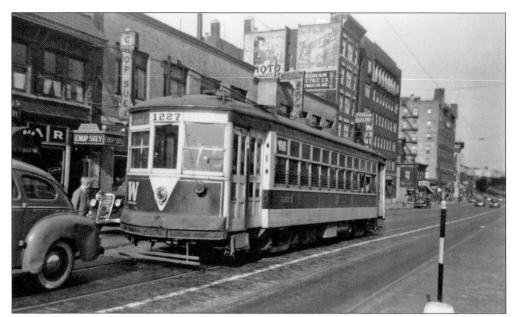

This is a 1938 view of the W line trolley heading south on Webster Avenue. This trolley saw service in Poughkeepsie, New York, and Eau Claire, Wisconsin, before arriving in the Bronx. A chop suey restaurant is on the left, and a pool hall is above the bar on the left. In the right background, the Third Avenue El crosses onto Webster Avenue at 197th Street. (Courtesy of Bill Armstrong.)

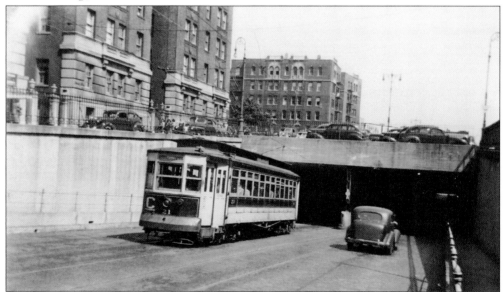

This C line trolley is on the Bronx and Van Cortlandt Parks line, which operated between Fordham Road and Southern Boulevard and the city line at Broadway and 262nd Street. The line was known as the "monkey line" since it served the Bronx Zoo. This convertible streetcar was built by the J.G. Brill Company of Philadelphia in 1909 and was fitted with removable windowed side panels, which could be replaced by screens during the warmer summer months. It is seen here emerging from the Kingsbridge Road underpass under the Grand Concourse. (Courtesy of Bill Armstrong.)

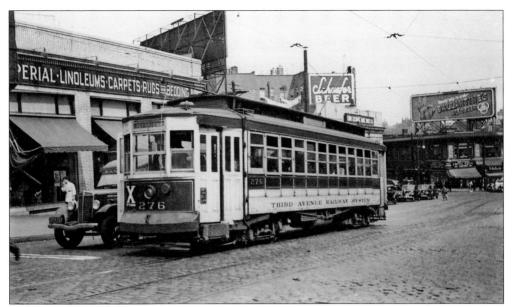

This number 276 streetcar, manufactured by Brill in 1911, is on the 207th Street crosstown line traveling west on Fordham Road at Marion Avenue. It is heading for its western terminus at Broadway and 207th Street, and the photograph was taken on September 23, 1940. (Courtesy of Bill Armstrong.)

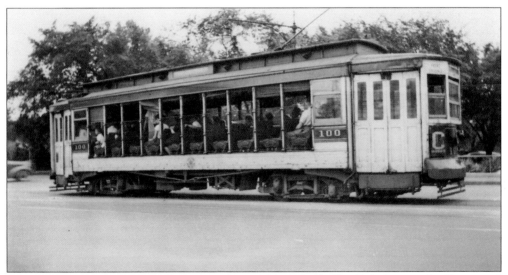

This convertible streetcar (trolley) bears the number 100 (Brill, 1909). It is on the Bronx and Van Cortlandt Parks C line. The line operated between Fordham Road and Southern Boulevard and the city line at Broadway and 262nd Street. This red and tan convertible streetcar was fitted with screens during the summer of 1942. The streetcar is seen passing the Bronx Zoo, located at Fordham Road and Southern Boulevard. (Courtesy of Bill Armstrong.)

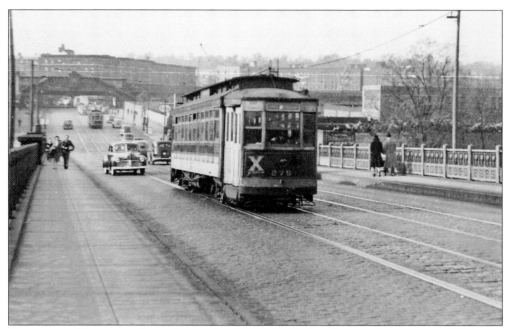

This convertible streetcar bears the number 275 (Brill, 1911) and is traveling east on 207th Street across town. It is on the approach to the University Heights Bridge, and the 207th Street station of the original Interborough subway is in the background. (Courtesy of Bill Armstrong.)

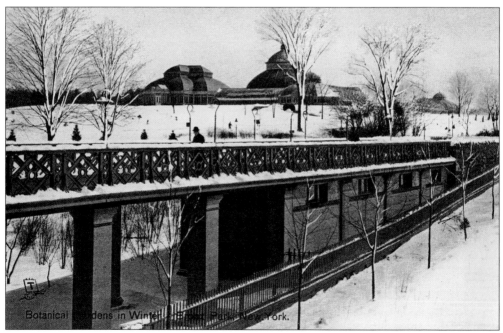

The 1909 winter view shows the elaborate platform of the Third Avenue El station. The Enid A. Haupt Conservatory, which opened in 1902, welcomed visitors arriving by subway. This special Botanical Garden Station opened in May 1902 and was removed in November 1951.

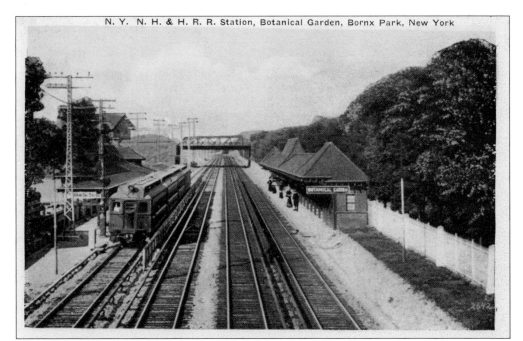

A train of the New York, New Haven, and Harlem River Railroad has just pulled into the Botanical Garden Station. This is a southbound train that will make its final stop at Grand Central terminal. The waiting passengers probably spent the day at the Botanical Garden to the right of the station. Fordham Station is to the south and Woodlawn Station is to the north, which parallels the Bronx River just east of the rail line. The Mosholu Parkway overpass is visible in the center of the image. The landmark 52nd Precinct building is visible at the upper left side of this c. 1920 image.

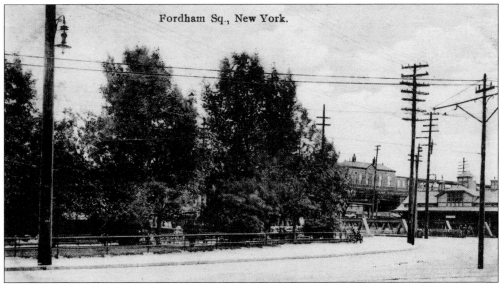

Fordham Sq., New York.

This is a 1912 view of the corner of Webster Avenue and Fordham Road. The New York Harlem Division train station is at ground level on the south side of Fordham Road. The steel trusses are for the bridge over the tracks. The building in the right background is the station house platform for the Third Avenue El. Note the absence of cars and buses.

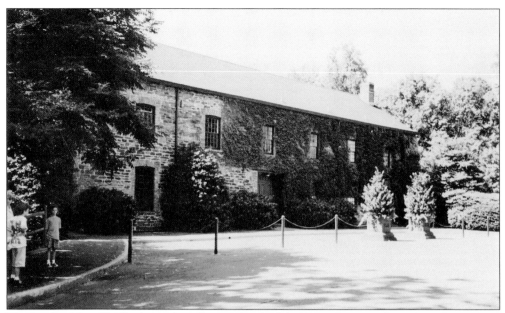

The Lorillard Snuff Mill is located on the west bank of the Bronx River in the New York Botanical Garden. It was built around 1845, and the swiftly flowing river turned the millstones for many years. The Lorillard family maintained an acre of roses, and the petals were ground with tobacco to scent the snuff. Extensive restoration work turned the mill into a catering facility in 1995, and a complete renovation took place in 2010.

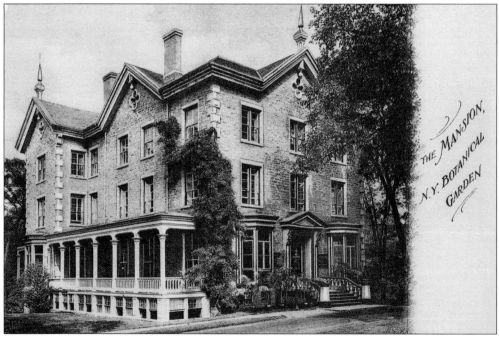

The Lorillard Mansion, built in the 1850s, was located on the Bronx River just below the falls and hemlock forest. The Lorillard family had a 600-acre working farm and ran a snuff mill down from the mansion on the Bronx River. The building later served as a police station until it was destroyed by fire in 1923.

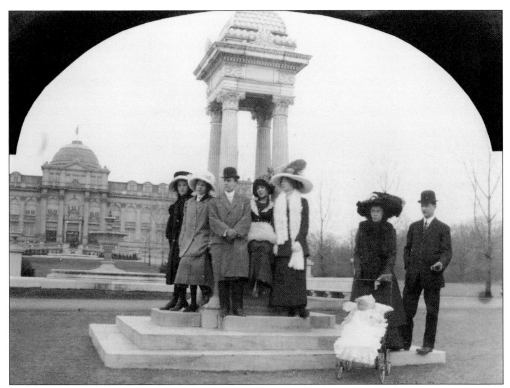

The New York Botanical Garden is located east of Webster Avenue and northeast of Fordham University. In 1891, Fordham University sold 250 acres for $1,000 with the restriction that the property be used for a zoo or garden. The museum building was designed by architect Robert W. Gibson and was built between 1899 and 1901. The fountain, concrete benches, and the ornamental Italianate structure have since been removed.

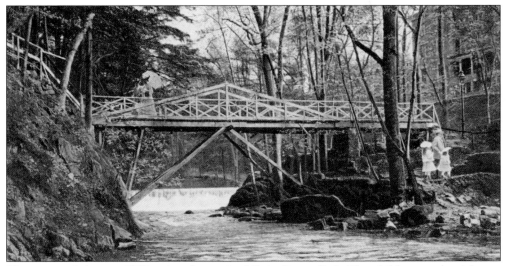

This postcard shows a 1909 spring day at the falls in Bronx Park. The children on the right are dressed in pink and yellow, while the ladies on the bridge carry a yellow parasol. The view is toward the hemlock forest to the north. The bridge is no longer wooden, and the Lorillard Mansion on the right side has been razed.

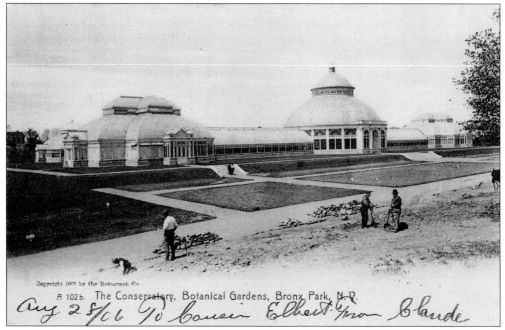

A 102 b. The Conservatory, Botanical Gardens, Bronx Park, N.Y.

Aug 25/06 To Cousin Elbert from Claude

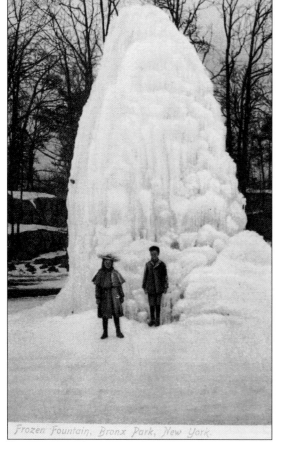

Frozen Fountain, Bronx Park, New York.

The original Enid A. Haupt Conservatory of the New York Botanical Garden, built by Lord and Burnham, was considered the largest greenhouse in the world when it was completed in 1902. It has been restored on several occasions, the latest being completed in 1995, although the building is currently being updated once again.

This is a 1900 winter view of the frozen fountain at the Botanical Garden. Note the typical winter dress of the day. The young boy is dressed in cap, boots, and overcoat, and the young girl has a long coat, boots, cape, and colorful flowering hat. The terra-cotta fountains, designed by Robert W. Gibson, the architect of the museum building, have been removed.

This is a 1920 photograph of Edith Aram at the New York Botanical Garden. Aram resided in the Bronx waterfront community of Edgewater Park and was the local photographer responsible for producing numerous postcards of that community during the late teens and early 1920s. (Courtesy of the John McNamara collection.)

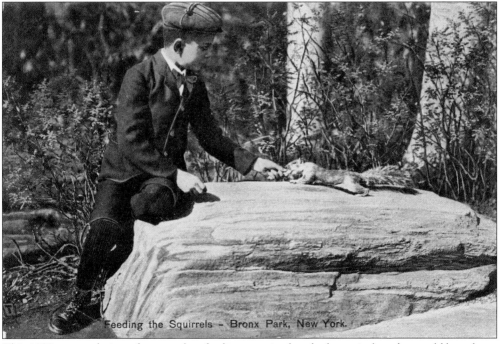

Feeding the Squirrels – Bronx Park, New York.

This 1909 postcard view of a young boy feeding a squirrel at the botanical garden could have been produced last week—except for his clothing. He is wearing a cap, red tie, jacket, and, of course, knickerbockers, which help date the picture.

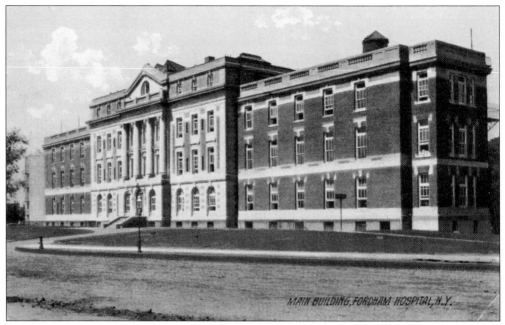

Fordham Hospital was the first city hospital for the emergency care of the general public. It opened in 1892 at Valentine Avenue near Kingsbridge Road and moved to Aqueduct Avenue and St. James Place in 1898. Six years later, construction was underway at Southern Boulevard and Fordham Road for the building depicted here.

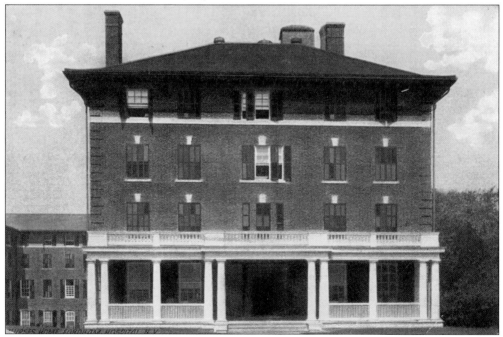

This is a 1909 view of the five-story Nurses Home, looking out toward the Bronx Botanical Garden. It was part of the "new" 1904 Fordham Hospital that faced Southern Boulevard north of Fordham Road. By 1906, the home, stable, and laundry buildings were in place just north and to the rear of the hospital.

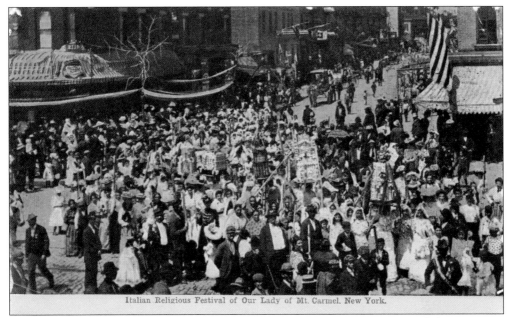

Italian Religious Festival of Our Lady of Mt. Carmel, New York.

This is a 1909 view of the Italian religious festival of Our Lady of Mount Carmel at Crescent Avenue and 187th Street looking toward Belmont Avenue. The basement church opened in 1907 on Christmas Day and seats 750. The upper church opened in 1912. Bronx-born Dion DiMucci of the Belmonts singing group still dines at the some of the renowned Arthur Avenue Italian restaurants.

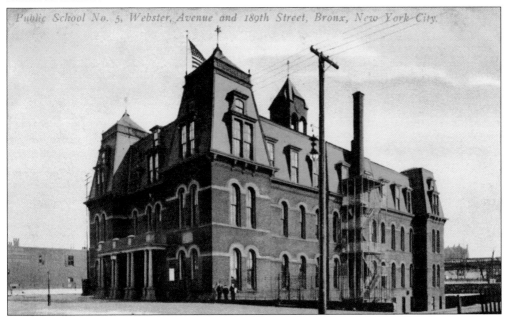

Public School No. 5, Webster Avenue and 189th Street, Bronx, New York City.

This is a 1909 view of Public School No. 5, located on the east side of Webster Avenue at 189th Street. The Third Avenue El is visible in the rear. The school is three stories, red brick, and was designed in a high Gothic style with a mansard roof. It was built in 1873 and 50 years later closed due to poor conditions. It was later used for offices of the Home Relief Agency until a fire on December 22, 1936, closed the doors for good.

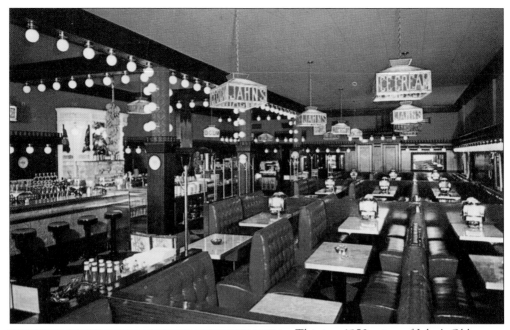

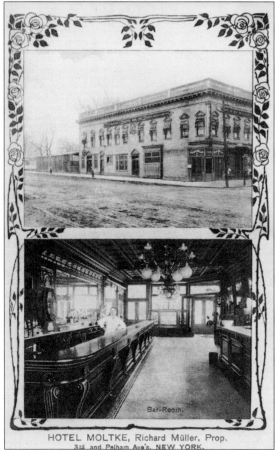

HOTEL MOLTKE, Richard Müller, Prop.
3rd and Pelham Ave's. NEW YORK.

This is a 1950s view of Jahn's Old Fashioned Ice Cream Parlor, which was located at 294 East Kingsbridge Road at Fordham Road. John Jahn opened his first ice cream parlor in the Bronx in 1897 at 138th Street and Alexander Avenue. It was popular site for dinner dates and after-movie specialty desserts. Some desserts were Tall-in the Saddle, the Thing, the Tree, and the Kitchen Sink. The Bronx Library Center opened on the Jans location in 2006.

This is a 1909 double view of Hotel Moltke, at the northeast corner of Third Avenue and Pelham Avenue, showing the hotel above and the barroom with Richard Muller, the proprietor, below. Muller, an American, would receive a Maltese Cross from Kaiser Wilhelm II (1859–1941) in Germany on the occasion of the kaiser's 50th birthday. Pelham Avenue is now known as Fordham Road.

In the 1920s, residential houses in the Bronx were greatly expanding, and postcards were used to advertise this five-story building. James H. Jones had his store at the southwest side of Marion Avenue at 350 Fordham Road. The site is now occupied by a variety of shops.

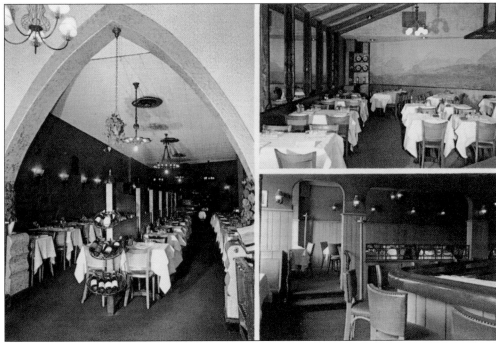

This is a 1950s interior view of the Lido Riviera Restaurant located at 313 East Kingsbridge Road at Fordham Road. The Lido was established in 1927 and was next door to the popular 1,600-seat Windsor Theatre. Fordham University won the 1942 Sugar Bowl over Missouri and celebrated their bowl party at the Lido. The Windsor closed in the early 1950s and the Lido in the 1960s.

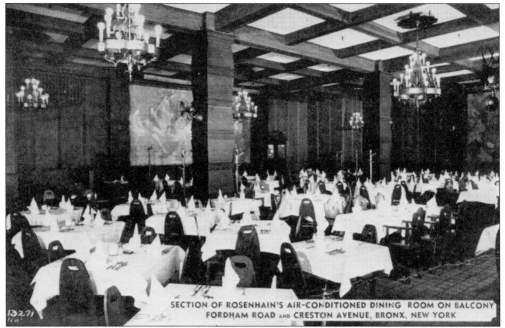

SECTION OF ROSENHAIN'S AIR-CONDITIONED DINING ROOM ON BALCONY
FORDHAM ROAD AND CRESTON AVENUE, BRONX, NEW YORK

Located at Fordham Road and Creston Avenue, Rosenhain's fine dining was the place to be in this 1940 view. In 1932, Rosenhain's made history by being the place where John "Jafsie" Condon, boxer Al Reich, and Charles Lindbergh met to plan the return of the Lindbergh child from his kidnappers.

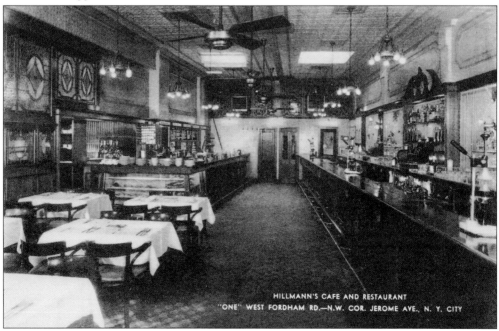

HILLMANN'S CAFE AND RESTAURANT
"ONE" WEST FORDHAM RD.—N.W. COR. JEROME AVE., N. Y. CITY

According to the above postcard, Hillmann's casual dining was located at the "Cross Roads of the Bronx" at the northwest corner of Fordham Road and Jerome Avenue. Hillmann advertised on the postcard that his air-conditioned restaurant had "Fine Food Carefully Prepared" for catering and for parties.

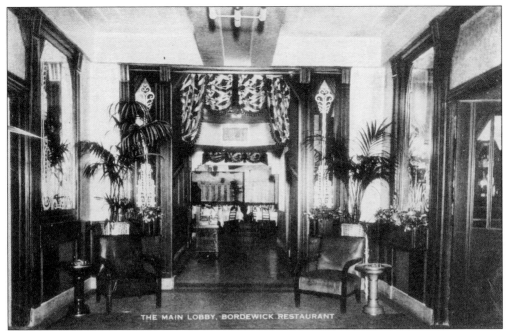

THE MAIN LOBBY, BORDEWICK RESTAURANT

The Bordewick Restaurant offered the very finest in foods, liquors, and freshest seafood. Weddings, banquets, and socials were offered at moderate prices. There were two entrances, one at the southwest corner of Valentine Avenue and the other at 226 East Fordham Road opposite the RKO Theater.

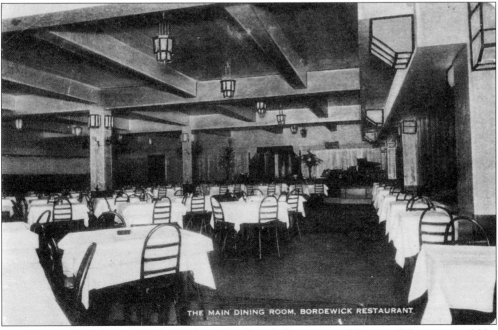

THE MAIN DINING ROOM, BORDEWICK RESTAURANT

The tables are set for a Saturday night at Bordewick Restaurant. Music and dancing could be provided to 400 patrons at this American-style restaurant. The band is set up in the back, stage right. A Foot Locker shoe store now occupies the site.

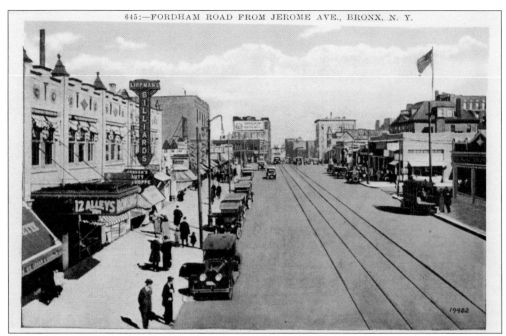

This marvelous view of East Fordham Road was taken from Jerome Avenue. People can be seen on the wide sidewalks of the thoroughfare along with over a dozen now vintage vehicles. The bowling alley at the left advertises 12 lanes, and the huge Lippman's Billiards sign beckons passersby to stop and spend some time. Both activities were popular pastimes during that era. Note also the two sets of trolley tracks on East Fordham Road.

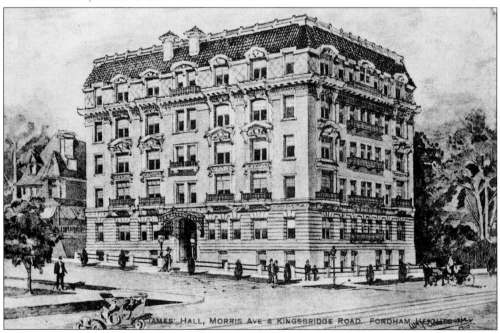

This is a 1912 architect's view of the St. James Hall apartment house located at the northeast corner of Morris Avenue and Kingsbridge Road. The main entrance is on Morris Avenue. The steel balconies are now fire escapes and numerous ground level stores line Kingsbridge Road.

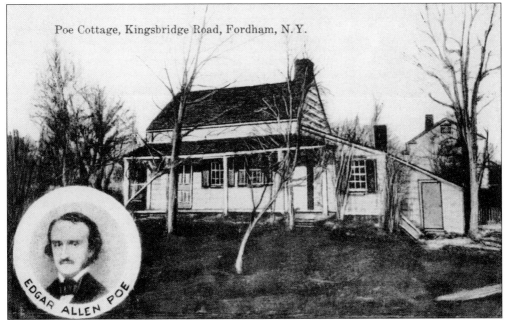

Poe Cottage, Kingsbridge Road, Fordham, N.Y.

The Poe Cottage is believed to have been built by John Wheeler around 1812. It has a stone fireplace and brick hearth in the downstairs parlor, along with a small bathroom and a lean-to kitchen. There are two small bedrooms upstairs. The cottage was located at Kingsbridge Road and 192nd Street but has since been moved to Poe Park. Edgar Allan Poe, his wife, Virginia, and mother-in-law, Maria Clemm, lived here from 1846 until Poe's death on October 3, 1849.

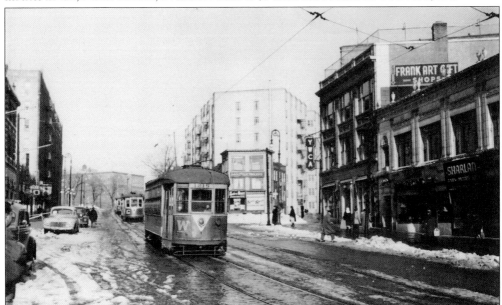

This W trolley number 1215 was built by Osgood-Bradley in 1924. Purchased secondhand from the Richmond Railways of Staten Island, it is traveling eastbound on Kingsbridge Road near Briggs Avenue as a run-on for the Webster Avenue and White Plains Road line. Notice the YWCA at the right in this snow scene. Poe Park would be off in the background. (Courtesy of Bill Armstrong.)

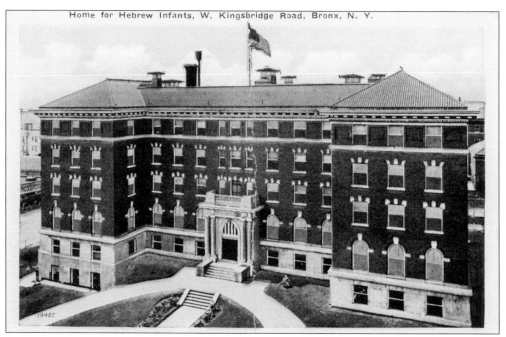

Home for Hebrew Infants, W. Kingsbridge Road, Bronx, N. Y.

Founded in 1895, the Hebrew Infant Asylum changed its name to the Home for Hebrew Infants. In 1911, they expanded from a small frame dwelling on Mott Avenue to a five-story complex on the south side of West Kingsbridge Road and University Avenue that was designed by Edward Necarsuler. Shelter was provided to the children, and the study of hereditary illness, childhood nutrition, and sterilization was greatly advanced at the Home for Hebrew Infants.

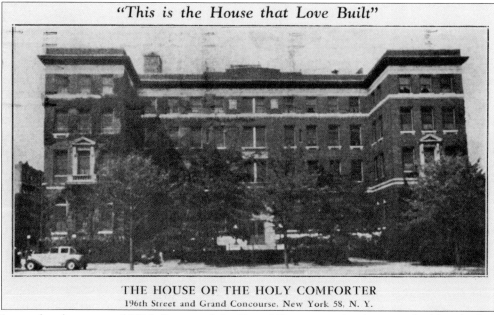

"This is the House that Love Built"

THE HOUSE OF THE HOLY COMFORTER
196th Street and Grand Concourse, New York 58, N. Y.

Located at the corner of 196th Street and the Grand Concourse, this four-story building had its cornerstone laid on December 3, 1914, as the Home for the Incurable by the Protestant Episcopal Church. Care was provided for women and children. It is now used by the University Neighborhood Housing Program ,and the House of the Holy Comforter moved to Cortlandt, New York.

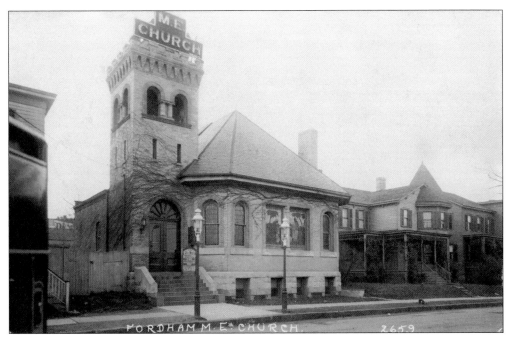

The old Fordham Methodist Episcopal Church was located on Marion Avenue, just north of Fordham Road. The gas lights in front, the church, and frame house are gone. In the 1960s, the church had an active Methodist Youth Fellowship even though it was located in this predominantly Irish and Italian neighborhood. The new church is the Fordham United Methodist.

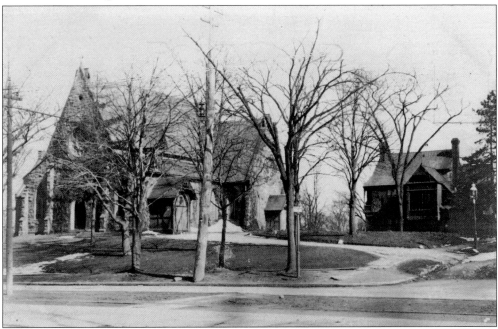

This is a 1909 view of St. James Episcopal Church. The parish was established in 1853, and the church was constructed in 1865 at Jerome Avenue just north of 190th Street. The residence on 190th Street may have been the family home of architect Charles B.J. Snyder, who lived at number 387. There are six Louis Comfort Tiffany stained glass windows in the church.

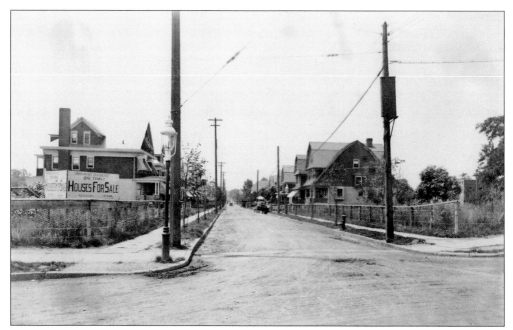

The photographer was looking south from Kingsbridge Road when he took this picture of Grand Avenue in December 1913. The sign at left reads, "Grand Avenue restricted one family houses for sale, plots 50 x 100, T. M. Thorn." Note the vintage street lamp at the left. (Courtesy of Lou Testa.)

This is a photograph of a southern entrance to the old Claffin estate that was taken in 1913. The Claffins, wealthy New York merchants, owned most of the land north of Kingsbridge Road between Sedgwick Avenue and Reservoir Avenue. (Courtesy of Lou Testa.)

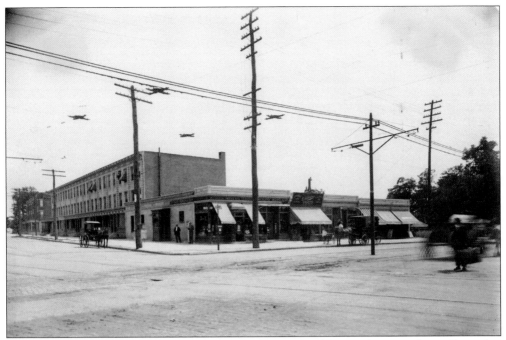

This is a photograph of the intersection of Kingsbridge Road and Jerome Avenue, taken in December 1913. Kingsbridge Road goes off to the left and Jerome Avenue to the right. Note the trolley tracks and the two different horse and wagons off either corner. (Courtesy of Lou Testa.)

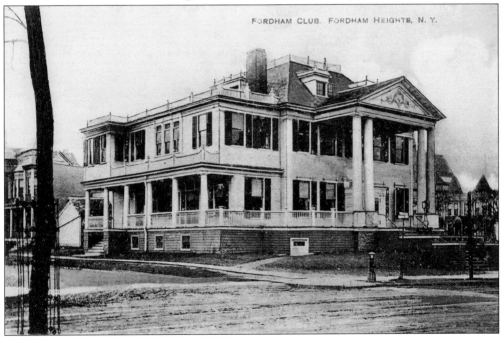

FORDHAM CLUB, FORDHAM HEIGHTS, N. Y.

This 1909 view of the Fordham Club, a private club not affiliated with Fordham University, shows the three-story brick and frame structure at the southwest corner of Morris Avenue and Fordham Road. Morris Avenue is now known as Monroe College Way, and the club has been replaced by a commercial structure. The club is gone but the residences on the left still are standing.

This 1913 photograph shows Jerome Avenue going off to the left from Kingsbridge Road. There are barricades on both sides of Jerome Avenue, and the one at the right reads "street closed." There is a "for sale" sign on the tree to the right of the houses. (Courtesy of Lou Testa.)

This 1913 photograph was taken from Kingsbridge Road and looks south on Davidson Avenue, which is only a dirt path. The houses at the right face Grand Avenue to the west. (Courtesy of Lou Testa.)

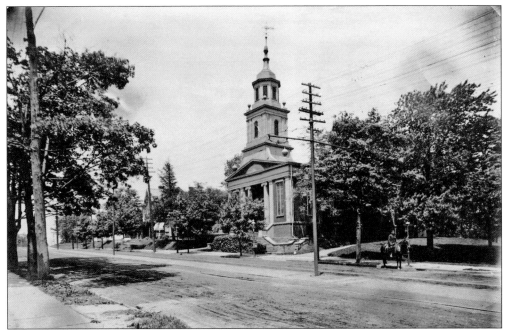

This is a 1915 photograph of the Fordham Manor Dutch Reformed Church. It is located on the north side of Kingsbridge Road at Reservoir Avenue and was built in 1848 and enlarged in 1878. A new church was subsequently constructed around the corner. (Courtesy of Lou Testa.)

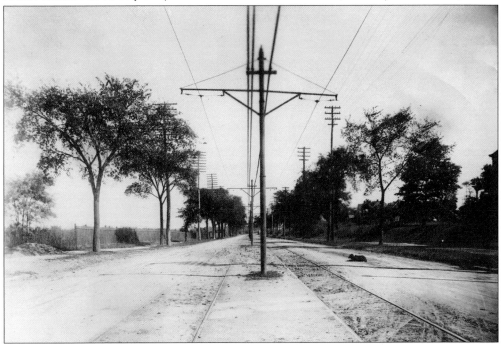

The photographer was looking north on Jerome Avenue in 1913 when he took this marvelous photograph. The view is from just north of Kingsbridge Road, and Jerome Park Reservoir would be off to the left. Note the dog resting in the roadway at the right and the trolley poles down the center of the street. (Courtesy of Lou Testa.)

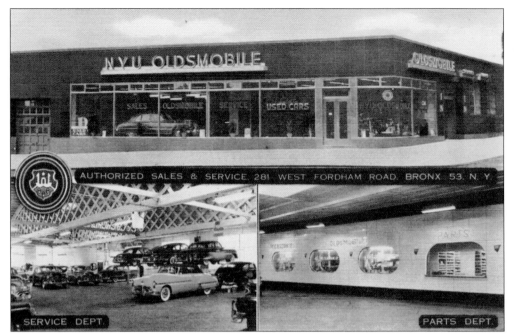

AUTHORIZED SALES & SERVICE. 281 WEST FORDHAM ROAD. BRONX 53. N. Y.

SERVICE DEPT.

PARTS DEPT.

The New York University Oldsmobile dealership was located at 281 West Fordham Road in 1940. Nearby New York University would sell its Bronx campus, and NYU Oldsmobile would become Jimmy's Bronx Café. Bronx-born Jimmy Rodriquez opened his 300-seat world famous restaurant there in 1993, but overexpansion led to a 2004 closing, and now it is a Dallas BBQ franchise.

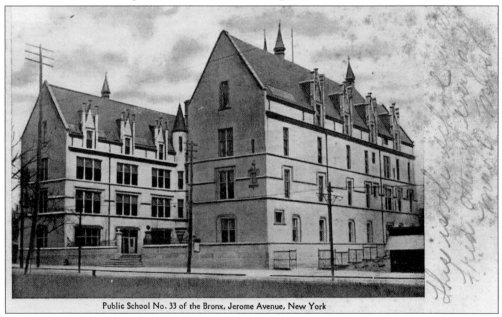

Public School No. 33 of the Bronx, Jerome Avenue, New York

Public School 33, located at Jerome Avenue just below Fordham Road, is viewed in 1906 before the Jerome Avenue line of the elevated subway would cross the front courtyard. Charles B.J. Snyder, who lived in the Fordham section from 1893 to 1904, was the architect for this chateau-style school. Snyder, who is buried at Woodlawn Cemetery, designed over 400 New York City schools from 1891 to 1923.

Two

BEDFORD PARK

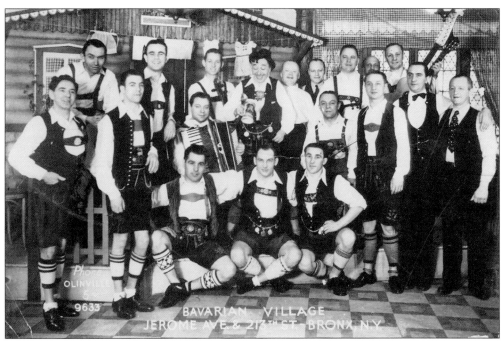

By 1901, the south Bronx was home to numerous German breweries. Prohibition (1920–1933) displaced many brewery workers, causing an influx to the northwest Bronx and Westchester County. The Bavarian Village replaced the Woodlawn Inn at Jerome Avenue and 213th Street opposite the Mosholu Golf Course. Golfers could enjoy a cold stein of beer until the Bavarian Village closed at the start of World War II.

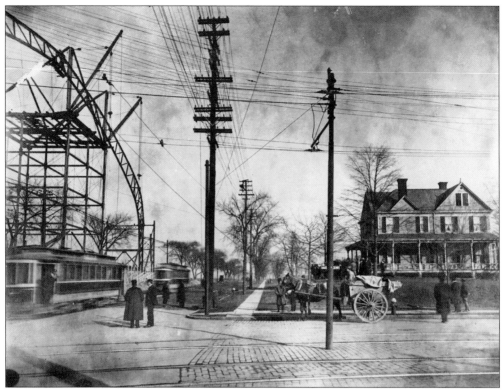

The photograph above is the Kingsbridge Armory under construction in 1913 and viewed from Kingsbridge Road looking north up Jerome Avenue. The two trolleys can be seen on Jerome Avenue. Note the cobblestone roadway in the foreground and the Department of Street Cleaning cart at the curb. There are more than a dozen people in the picture, which seems rather significant for such an early date. Construction of the armory began in 1912 and was completed in 1917. The postcard below displays the completed armory in 1917. It was designed by Pilcher and Tachau and was touted as the largest armory in the world. (Above, courtesy of Lou Testa.)

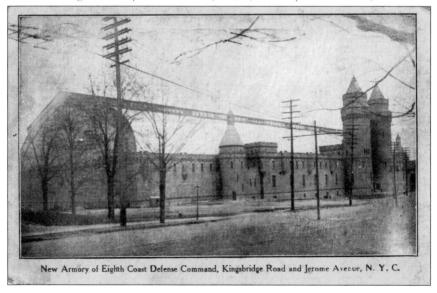

New Armory of Eighth Coast Defense Command, Kingsbridge Road and Jerome Avenue, N. Y. C.

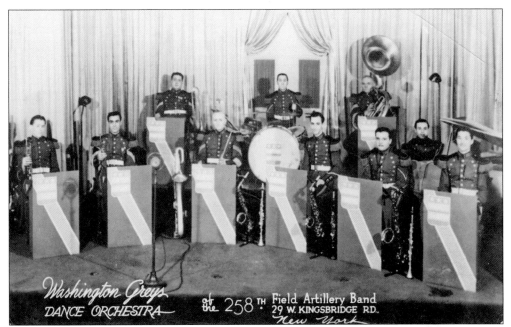

The Kingsbridge Armory at 29 West Kingsbridge Road at the corner of Jerome Avenue was the venue for a night out on the town. The Washington Grey's Dance Orchestra of the 258th Field Artillery Band entertained women from the US Naval Training School, the Army, and New York State National Guard, along with many Bronx locals during the 1940s. Kingsbridge Armory, a New York City landmark, was the largest indoor open space venue until the Houston Astrodome opened for baseball in 1965.

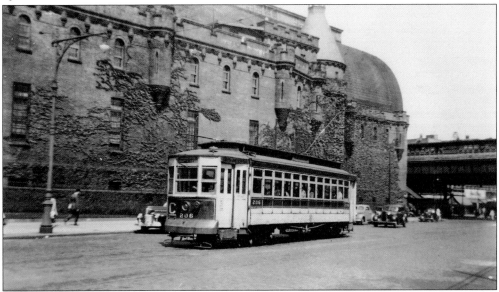

This convertible streetcar built by J.G. Brill Company in 1911 bears the number 206. The "C" on the front panel indicates the route, the Bronx Zoo to Van Cortlandt Park. The car line is traveling west on Kingsbridge Road just west of Jerome Avenue. It is passing the Kingsbridge Armory (8th Regiment Armory), which was said to be the largest armory in the world with its drill deck the size of four football fields. (Courtesy of Bill Armstrong.)

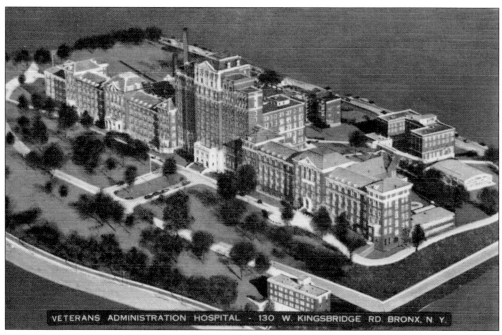

VETERANS ADMINISTRATION HOSPITAL - 130 W. KINGSBRIDGE RD. BRONX, N. Y.

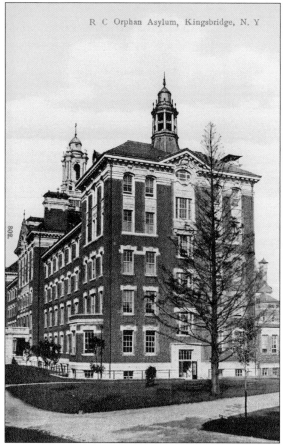

R C Orphan Asylum, Kingsbridge, N. Y

This 1930s image of the Veterans Administration Hospital at 130 West Kingsbridge Road still retains the boys' and girls' wings of the former Roman Catholic Asylum. When acquired by the Veterans Administration in 1922, it was the second largest Veterans Administration Hospital in the nation with 1,663 beds. It was named the James J. Peters Veterans Administration Medical Center in 2005 to honor the former executive director of the Eastern Paralyzed Veterans Association.

The Roman Catholic Orphan Asylum, built in 1902, was located on the former 26-acre estate of Nathaniel Platt Bailey on the south side of West Kingsbridge Road between Sedgwick and Webb Avenues. Two five-story redbrick buildings were constructed for girls and boys. Today only the 1880 chapel of the Bailey estate is still in use.

Webb Academy, built to train shipbuilders, is located at Sedgwick Avenue and Fordham Road. Construction began in 1891, and the school opened in January 1894. William Henry Webb, a shipbuilder, endowed the tuition-free students and reserved a section of the building as a home for retired shipbuilders. It moved to the former Pratt Mansion in Glen Cove in 1947 and still excels in teaching marine engineering and naval architecture.

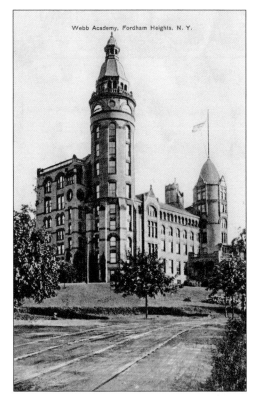

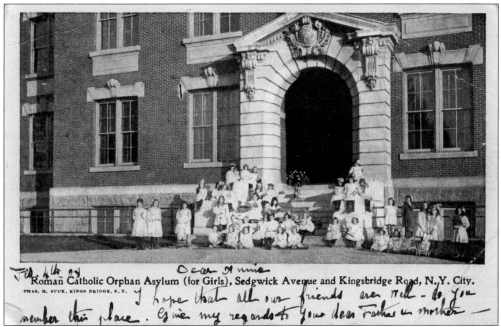

This postcard of the Roman Catholic Orphan Asylum was mailed on February 4, 1908, to Denver, Colorado, asking Anna O'Leary, "Do you remember this place?" The orphan asylum property was acquired in 1899 by Archbishop Michael Corrigan for $290,000 and run by the Sisters of Charity. There were two identical five-story buildings, one for girls and one for boys.

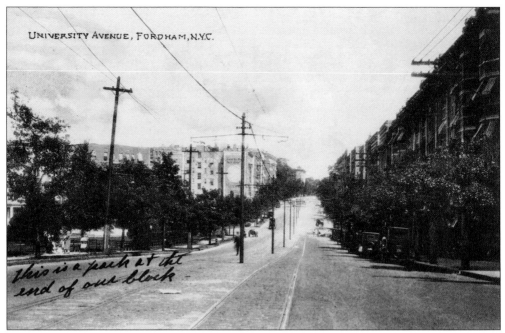

this is a park at the end of our block —

Dual trolley tracks line University Avenue looking north from Fordham Road to Kingsbridge Road at the top of the hill. The center of University Avenue is lined with numerous trolley poles that carried the electric power. Devoe Park is on the left, and an advertisement on the side of a building is for Maxwell House Coffee stating "Good to the last drop."

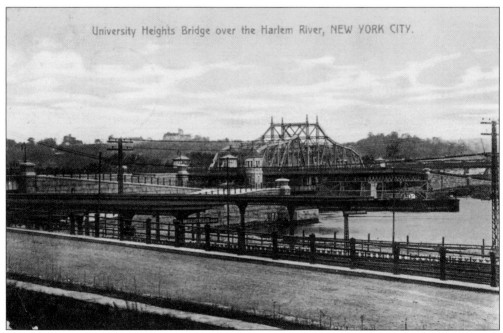

University Heights Bridge over the Harlem River, NEW YORK CITY.

The University Heights Bridge spans the Harlem River at West 207th Street and West Fordham Road. As a swing bridge, it was opened to traffic on January 8, 1908. It is 25 feet above the mean high watermark.

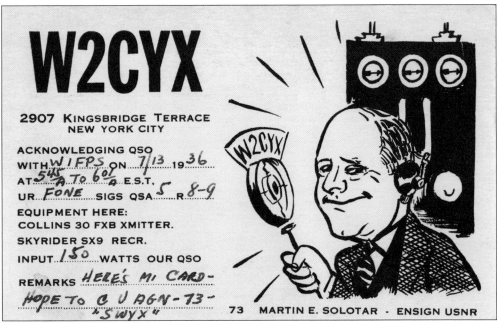

W2CYX

2907 KINGSBRIDGE TERRACE
NEW YORK CITY

ACKNOWLEDGING QSO
WITH *WIFPS* ON *7/13* 19*36*
AT *5⁴⁵A* TO *60¹⁄₂* E.S.T.
UR *FONE* SIGS QSA *5* R *8-9*

EQUIPMENT HERE:
COLLINS 30 FXB XMITTER.

SKYRIDER SX9 RECR.

INPUT *150* WATTS OUR QSO

REMARKS *HERE'S MI CARD-*
HOPE TO C U AGN - 73 -
"SWYX"

73 MARTIN E. SOLOTAR - ENSIGN USNR

Martin E. Solotar of amateur radio station W2CYX sent this 1936 QSL card from the Kingsbridge Heights section of the Bronx. A QSL card confirms that Solotar received a communication from another amateur radio station in a 6:00 a.m. transmission from Vermont. Solotar was an ensign in the US Naval Reserves in 1936, transmitting from the Bronx on W2CYX since 1920.

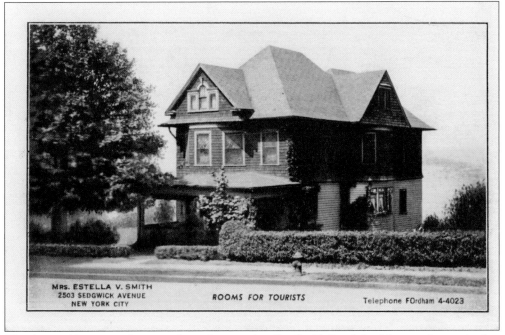

MRS. ESTELLA V. SMITH
2503 SEDGWICK AVENUE
NEW YORK CITY

ROOMS FOR TOURISTS

Telephone FOrdham 4-4023

This late 1930s postcard was used to advertise that Estella V. Smith had "rooms for tourists" at 2503 Sedgwick Avenue. This residence still commands the same view of the Harlem River and the New Jersey Palisades in the distance. Located just below the Veterans Hospital, this high ridge was home to defensive forts during the American Revolution in 1776.

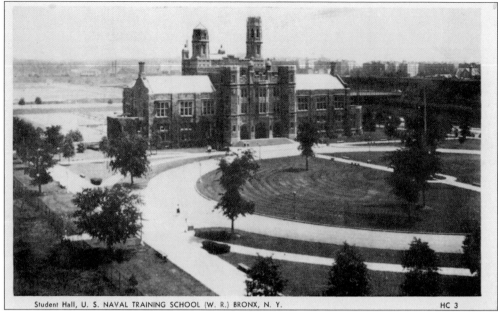

This Gothic-style building was known as the student hall on the Hunter College campus in 1944 and was used to train woman for the US Navy. Today it is the music building of Lehman College and retains the stained glass Navy anchor insignia above the front doors. The open field to the rear looking north would become Harris Park. Bronx High School of Science opened across from the park in 1959.

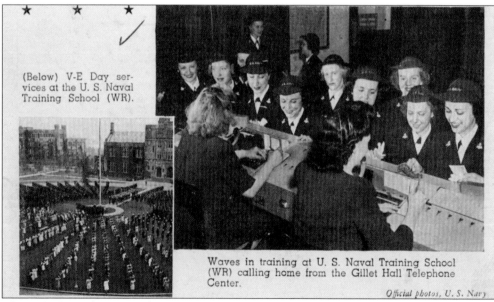

(Below) V-E Day services at the U. S. Naval Training School (WR).

Waves in training at U. S. Naval Training School (WR) calling home from the Gillet Hall Telephone Center.

Official photos, U. S. Navy

The WAVES and SPARS, the women's branches of the Navy and Coast Guard, were trained at Hunter College during World War II. The training facility was officially opened for them on February 8, 1943, and their main building was located at Bedford Park Boulevard and Paul Avenue. Hunter College moved there from Manhattan in the 1930s. A contract was signed for construction of the complex on the 40-acre site on August 14, 1929, and the buildings were sufficiently complete by 1936 for college use.

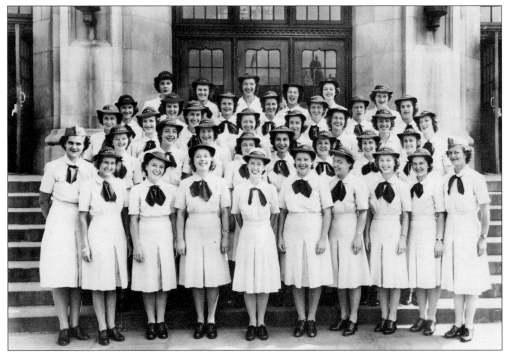

This is a July 1944 class photograph of one of the many graduates at the US Naval Training School for women from 1943 to 1945. Classes were taught at Hunter College, located on Bedford Park Boulevard east of the Jerome Park Reservoir. Over 95,000 WAVES from Hunter College served in critical positions for the US Navy.

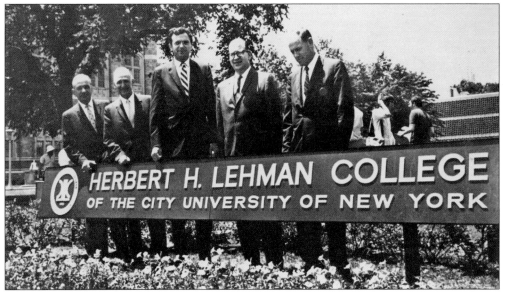

On July 1, 1968, Hunter College was officially renamed Herbert H. Lehman College and the sign attesting to that change was unveiled. Pictured from left to right are James R. Kreuzer, dean of the faculties; Wilbur Edel, dean of administration; Leonard Lief, the college president; Glen T. Nygreen, the dean of students; and Chester H. Robinson, the dean of the school of general studies. (Courtesy of Lehman College.)

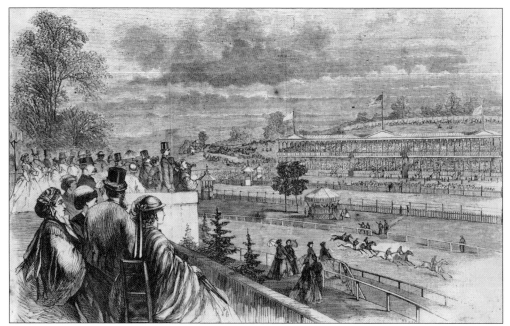

This is a September 25, 1866, view of the first race at the Jerome Park Race Track. The clubhouse was located on a small bluff facing east, and the grandstand had a view west to the New Jersey Palisades. Wealthy horse owners considered thoroughbred racing the sport of kings. They wished to supplant the old Bronx Fleetwood Track featuring trotters that pulled a two-wheeled cart.

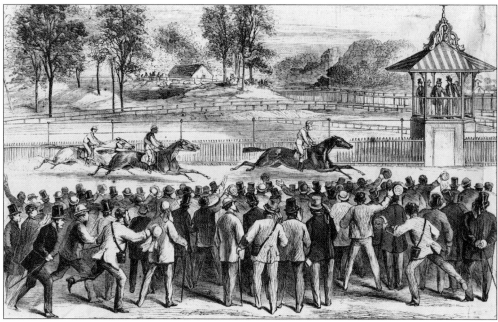

This is a Tuesday, September 25, 1866, *Frank Leslie's Illustrated Newspaper* image of the Grand Inauguration Race at the opening of the Jerome Park Racetrack at Fordham. The winning horse, Kentucky, is seen crossing the finish line. Leonard W. Jerome and August Belmont Sr. were the leading financiers and members. The track was sold to the City of New York in 1895 to develop the Jerome Reservoir, which was completed in 1907.

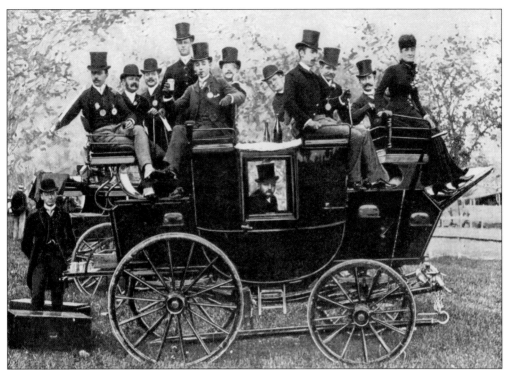

This 1888 photograph shows the coach party of Fredericka Belmont Howland and Nathaniel Griswald Lorillard at the Jerome Park Racetrack. Sadly, Lorillard died of lung disease at age 24 on November 4, 1888. Many in the grandstands arrived at the races by rail at Fordham, while members had access to a special rail spur to the track. The first Belmont Stake race was held here.

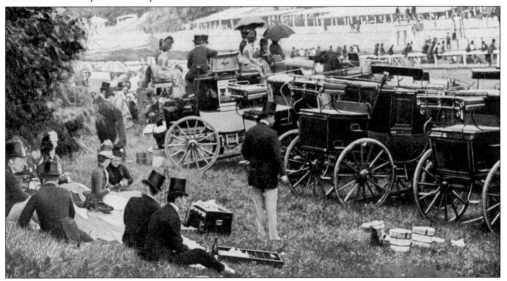

The clubhouse at Jerome Park Racetrack was built on a bluff overlooking the track and grandstands. The horse-drawn carriages that travelled from midtown Manhattan across the McCombs Dam Bridge and north on the new Jerome Avenue to the track are parked on the lawn. An 1888 lunch party on the lawn featured every luxury in food, wine, and silverware, which was presented by servants and coach staff.

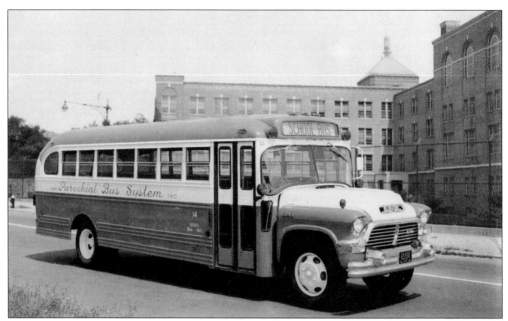

DeWitt Clinton High School was selected in the late 1950s to advertise the Parochial Bus System located at 3468 Park Avenue in the Bronx. This view is from Goulden Avenue. The school would have 12,000 students enrolled by the 1930s. As a coeducational institute, it currently lists 4,113 students. Former alumni include Judd Hirsh, Robert Klein, Ralph Lauren, Gary Marshall, Neil Simon, and Nate Archibald.

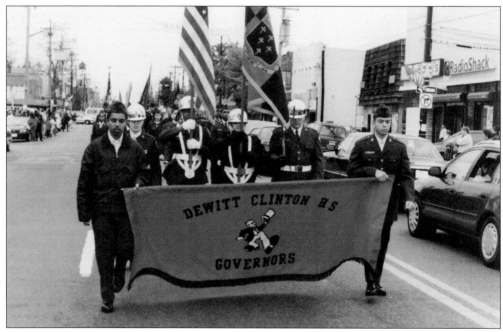

The Governors' Color Guard is leading the DeWitt Clinton High School Band down East Tremont Avenue in this photograph. The school was established in 1897 in Manhattan as a boys' school but moved to the Bronx in 1929. It is located on a 21-acre site at 100 West Mosholu Parkway South at West 205th Street. It became a coeducational school in 1983.

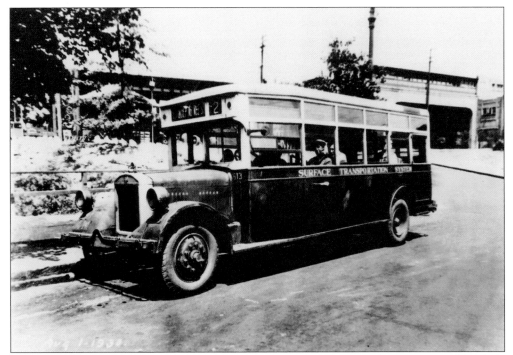

This is a 1930 picture of a Surface Transportation System bus at the Grand Concourse and Mosholu Parkway. This No. 2 line traveled south terminating at the Hub, which is located at 149th Street and Third Avenue. (Courtesy of Ron Schliessman.)

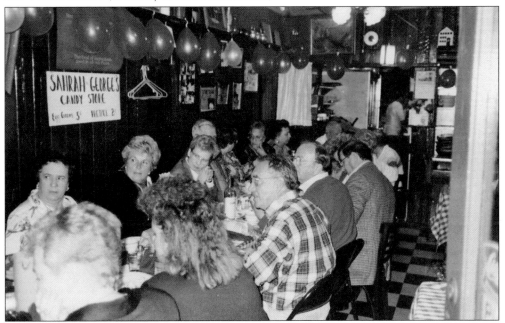

The Monti D'Oro Restaurant, located at 211 East 198th Street, held the 1994 reunion of the 1940s crowd from East 198th Street, Valentine Avenue, and the Grand Concourse. Their first reunion took place in 1977, and these revelers reminisced about Sarah and George's Candy Store and movies at the Decatur Theater, which was located on Webster Avenue until 1956.

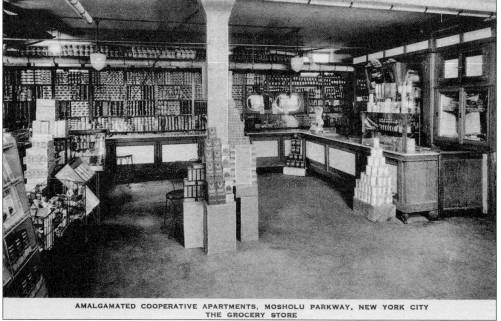

AMALGAMATED COOPERATIVE APARTMENTS, MOSHOLU PARKWAY, NEW YORK CITY
THE GROCERY STORE

The Amalgamated Cooperative Apartments grocery store was housed in the basement of this building. A shoe repair shop, barbershop, and a pharmacy were also maintained in the other buildings. The homeowner stockholder could buy shares in the various businesses at the cooperative. This was the first residential cooperative in the state of New York.

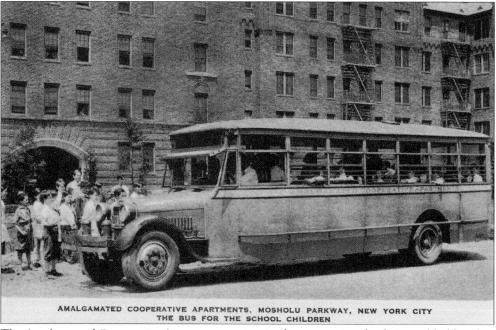

AMALGAMATED COOPERATIVE APARTMENTS, MOSHOLU PARKWAY, NEW YORK CITY
THE BUS FOR THE SCHOOL CHILDREN

The Amalgamated Cooperative Apartments maintained many services for their stockholders that included day care, a kindergarten, and their own bus. In this 1930s view, the Amalgamated bus is taking a group of children to school or on a trip. The bus also transported many of the resident garment workers to the local subway stations.

50

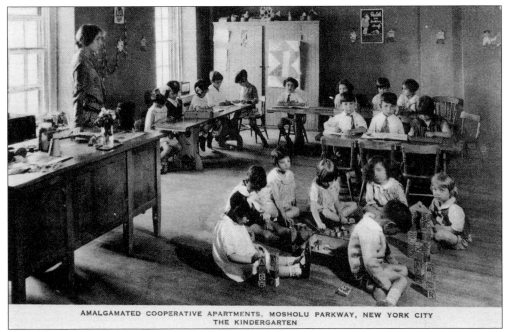

AMALGAMATED COOPERATIVE APARTMENTS, MOSHOLU PARKWAY, NEW YORK CITY
THE KINDERGARTEN

The Amalgamated Cooperative Apartments opened in 1927 between Sedgwick Avenue and Van Cortlandt Park South. There are beautiful water views of the Jerome Park Reservoir to the south and Van Cortlandt Park to the north. The first tenants were members of the Amalgamated Clothing Workers Union that built the Tudor-style complex. This kindergarten image is dated around 1930.

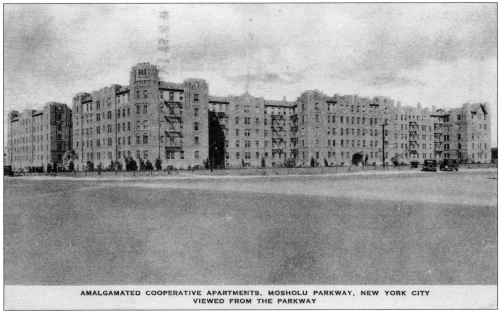

AMALGAMATED COOPERATIVE APARTMENTS, MOSHOLU PARKWAY, NEW YORK CITY
VIEWED FROM THE PARKWAY

The Amalgamated Cooperative Apartments is viewed from Mosholu Parkway looking west. The original 303 units were expanded in the late 1960s and now contain 1,482 units. High-rise towers replaced most of the five-story buildings. Many writers and artists joined the cooperative, enjoying art and dance classes, a barber, a store, and their own bus. This image is dated around 1930.

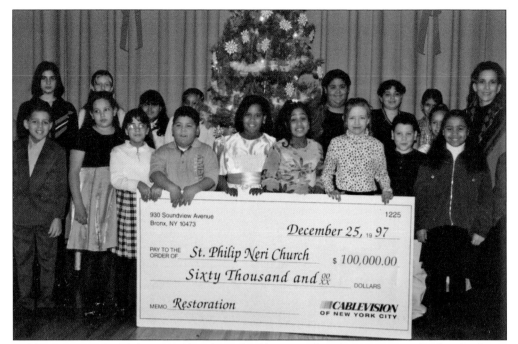

On the check:
930 Soundview Avenue
Bronx, NY 10473

1225

December 25, 19 *97*

PAY TO THE
ORDER OF *St. Philip Neri Church* $ 100,000.00

Sixty Thousand and oo⁄xx _____ DOLLARS

MEMO *Restoration*

CABLEVISION OF NEW YORK CITY

Cablevision gave St. Philip Neri Church a gift of $100,000 for Christmas in 1997. The check was meant to help rebuild the historic church after a devastating fire destroyed it on June 15 of that year. The church, located on the Grand Concourse at East 202nd Street in Bedford Park, was 97 years old, and the parish has about 3,000 members.

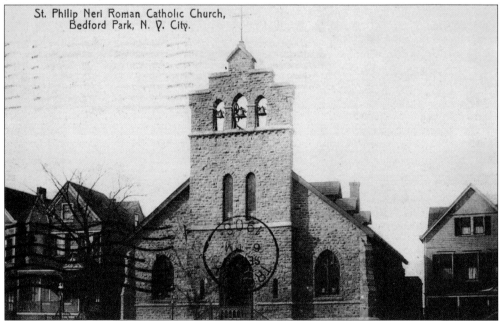

St. Philip Neri Roman Catholic Church, Bedford Park, N. Y. City.

St. Philip Neri Church was established in 1898, and the neo-Gothic building was completed the following year. It was dedicated in 1900 and is located at 3025 Grand Concourse at 202nd Street in Bedford Park. A great fire destroyed much of the church on the evening of June 15, 1997, and the church was rebuilt and dedicated by Edward Cardinal Egan on January 6, 2002.

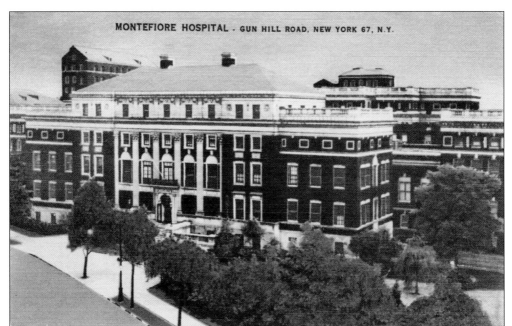

MONTEFIORE HOSPITAL - GUN HILL ROAD, NEW YORK 67, N.Y.

There was a time when Montefiore Hospital occupied only seven square blocks below Gun Hill Road. Wayne Avenue was to the east and Kossuth Avenue to the west with East 210th Street at the south. Much has changed over the years, and the little Jewish philanthropy that opened on East 84th Street and Avenue A in Manhattan in 1884 to help those with chronic diseases is now one of the largest hospital complexes in the nation, with over 17,000 associates. They moved to their first Bronx home at Gun Hill Road and 210th Street in 1913.

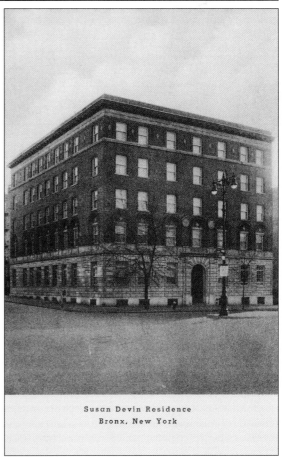

Susan Devin Residence
Bronx, New York

Susan Devin was a successful real estate investor in 1920 who endowed a residence for business women with hardships. It was run by the Sisters of Mercy at 2916 Grand Concourse at the southeast corner of East 199th Street. The Catholic Kolping Society of New York acquired the residence for men and women in 1980.

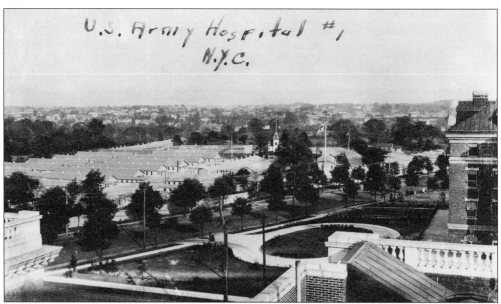

US Army Hospital No. 1 is viewed in 1918 from the roof of Montefiore Hospital with Gun Hill Road passing in front of the oval. The barracks and tents were named Camp Seuss after Commandant Jacob T. Seuss. The hospital complex covered East Gunhill Road, Bainbridge Avenue, and East 211th Street just south of Woodlawn Cemetery.

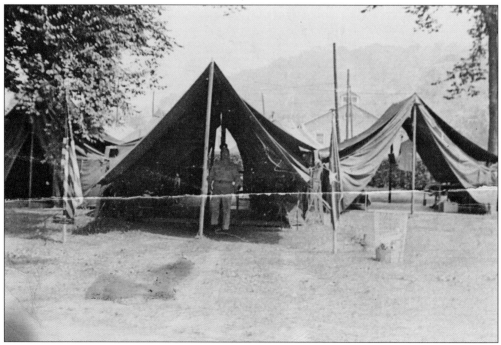

Camp Seuss was the unofficial name for the World War I hospital at Gun Hill Road and Bainbridge Avenue diagonally opposite Montefiore Hospital. The compound was officially called Chateau-Thierry for the town in Northern France where French and American troops defeated the Germans in 1918. This Louis V. Fucci photograph was taken when the camp opened. (Courtesy of the John McNamara collection.)

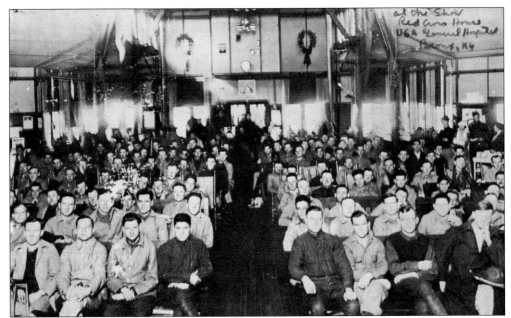

This is a December 1918 view of the interior of the Red Cross House at the Army Hospital No. 1 at Gun Hill Road. The site occupies the old Columbia Oval and Field that was transferred from Columbia University to the Army General Hospital in 1917. The open fields quickly became a hospital with 500 beds, and in six months, it expanded to accommodate 1,000 patients. The Columbia University gift is remembered in the street named after their original cognomen, Kings College Place.

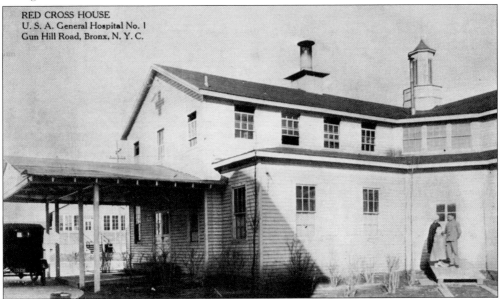

The Red Cross Hospital was located at the eastern point of the complex at today's Kings College Place on Gun Hill Road. Noteworthy Theodore Roosevelt's brother, Archibald B. Roosevelt, was injured in action with the 26th infantry in France on March 11, 1918. He received the Croix de Guerre in Paris and recovered from his injuries at the General Hospital No. 1 at Gun Hill Road in the Bronx.

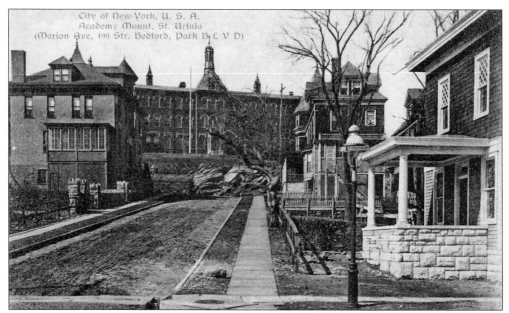

This 1909 view of Mount St. Ursula Academy was taken from Decatur Avenue looking uphill to Marion Avenue along East 199th Street. The school was established in 1855 by the Ursuline Sisters of the Roman Union and moved to the 10-acre Bedford Park campus in 1892. The residence on the south side of East 199th Street is still there.

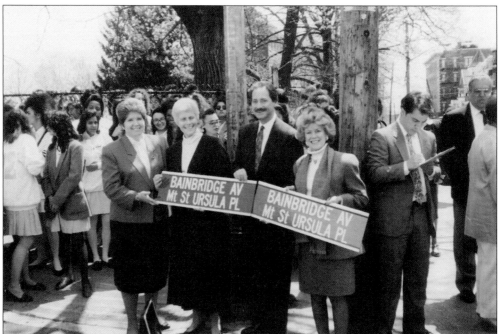

This 1992 photograph shows the Academy of Mount St. Ursula school administrators and students at the dedication of the street renaming and celebration of the 100th anniversary of the school at Bedford Park. The view is looking east from Bainbridge Avenue with East 198th Street on the right. Bronx borough president (1987–2001) Fernando Ferrer and city council member June M. Eisland officiated at the ceremony.

The Grand Boulevard and Concourse geographically divides the Bronx in half along the Fordham ridge. The roadway was completed from 161st Street to Mosholu Parkway at the north in 1909. Louis Aloys Risse conceived the design to include many transverse roads under the concourse. Construction at Bedford Park Boulevard is being prepared for an east to west crosstown trolley. The transverse road is viewed from the concourse west to Villa Street where the rear of St. Philip Neri Church is visible.

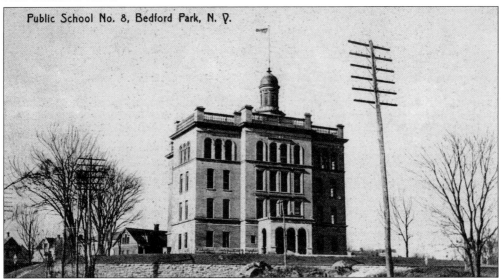

The Bedford Park area was a planned upscale residential neighborhood in 1898 when P.S. 8 was constructed. Architect Charles B.J. Snyder designed P.S. 8 and 57 other Bronx schools, of which 45 still remain open. This Bedford Park School at Bainbridge and Briggs Avenues, and fronting on Mosholu Parkway, was demolished in 1950 for construction of the Isaac Varian/ Briggs Academy.

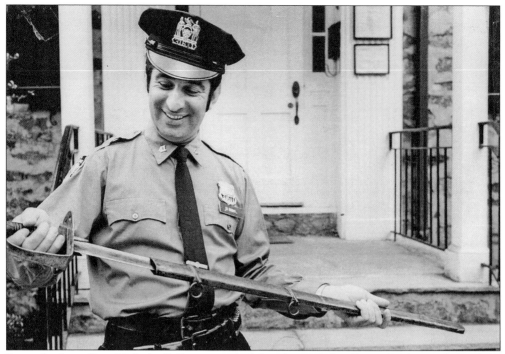

Retired police officer Nicholas DiBrino supplied this photograph of himself taken in front of the Valentine-Varian House in 1975. The historic building is located on Bainbridge Avenue at 208th Street. Nick is removing a Civil War sword from its scabbard to more carefully examine the relic. DiBrino is the author of *The History of the Morris Park Race Course and the Morris Family*, published in 1972. DiBrino is also a former trustee of the Bronx County Historical Society.

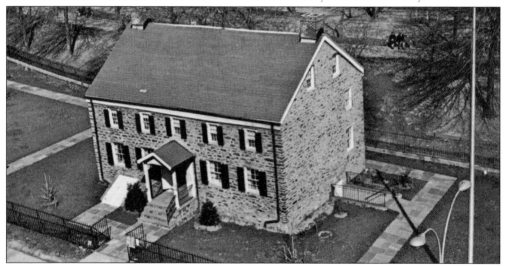

The Valentine-Varian House, built around 1750, was occupied by the British during the Revolutionary War. Gen. William Heath captured it and some of the occupants on January 18, 1777, without harming the building. The Valentine House passed to Isaac Varian in 1791 giving it today's cognomen, Valentine-Varian House. William F. Beller purchased it in 1905 and his son, William C. Beller, donated it to the Bronx County Historical Society in 1965. It is located on Bainbridge Avenue at East 208th Street.

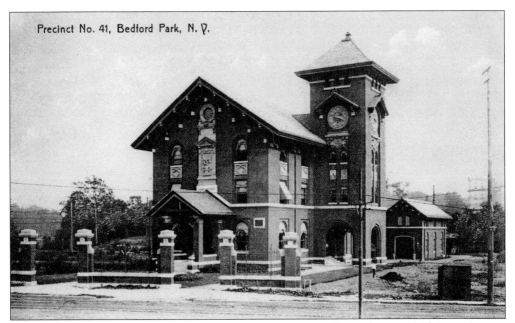

Precinct No. 41, Bedford Park, N. Y.

The 41st Precinct of the New York City Police Department, located at 3016 Webster Avenue off Mosholu Parkway, was renumbered the 52nd Precinct after this postcard was printed. It was designed by Stoughton and Stoughton and constructed between 1904 and 1906 in the Tuscan Italian Renaissance Villa style. It was named a New York City landmark in 1975.

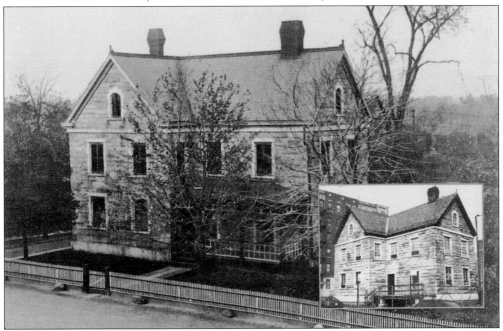

The Keepers House in Norwood was built in 1888 by the City of New York to serve as the home for the engineer who ran the Williamsbridge Reservoir, located at the corner of Reservoir Place and Reservoir Oval East. The need for the engineer's residence ceased to exist when the reservoir was drained in 1937. It held 150 million gallons of water when in use, and a park was later built on the site.

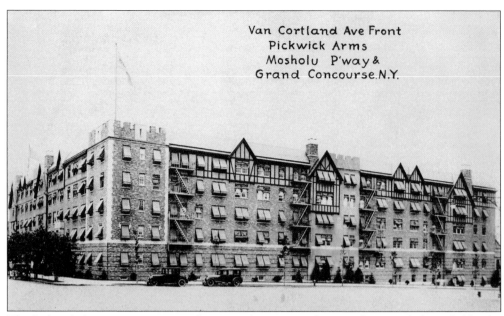

Van Cortland Ave Front
Pickwick Arms
Mosholu P'way &
Grand Concourse, N.Y.

The Pickwick Arms apartment complex opened in 1923 and covers the triangle bounded by the Grand Concourse, East Van Cortlandt Avenue, and East Mosholu Parkway South. The five-story, Tudor-style residence, containing a large interior courtyard, was created by architects Springsteen and Goldhammer is viewed facing East Van Cortlandt Avenue. The suburban homes of Bedford Park were rapidly being replaced, reaching a peak when the IND subway line opened in 1932.

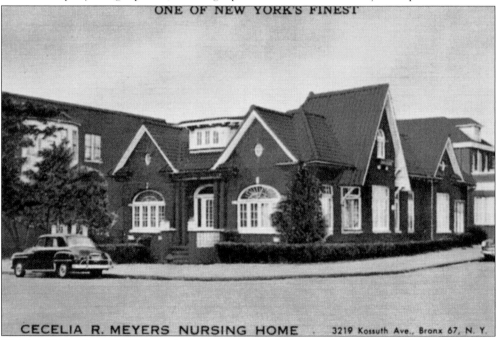

ONE OF NEW YORK'S FINEST

CECELIA R. MEYERS NURSING HOME . 3219 Kossuth Ave., Bronx 67, N. Y.

This is a 1940s view of 3219 Kossuth Avenue near 208th Street, advertising the Cecelia R. Meyers R.N. Nursing Home. Nearby Montefiore Hospital made the area a logical choice for the home and an outpatient facility. This cluster of homes would quickly be transformed into five-story apartment houses.

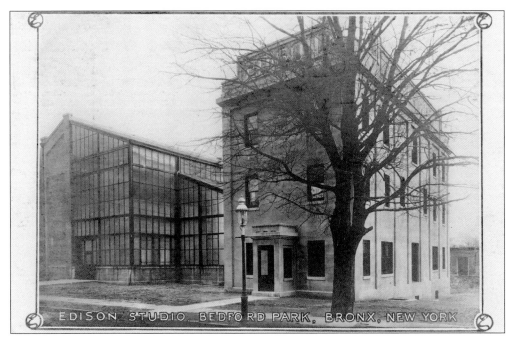

EDISON STUDIO BEDFORD PARK, BRONX, NEW YORK

The Edison Studio in Bedford Park was built at Decatur Avenue and Oliver Place in 1907. It was from this building that Thomas Alva Edison created some of his earliest silent films, such as *Alice's Adventures in Wonderland* in 1910. The studio was conveniently located near the Third Avenue El, and there was plenty of open space around for background shots.

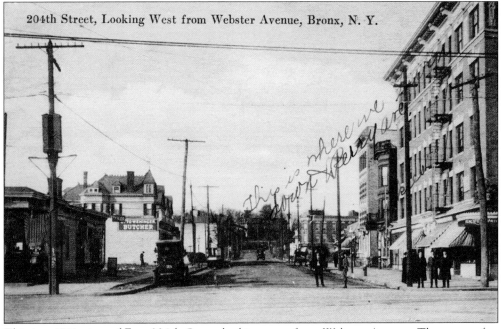

204th Street, Looking West from Webster Avenue, Bronx, N. Y.

This is a 1911 view of East 204th Street looking west from Webster Avenue. There were few automobiles along this busy commercial street at that time. The three-story building at the right rear is still at Hull Avenue along with the five-story apartment house in the foreground at Webster Avenue.

61

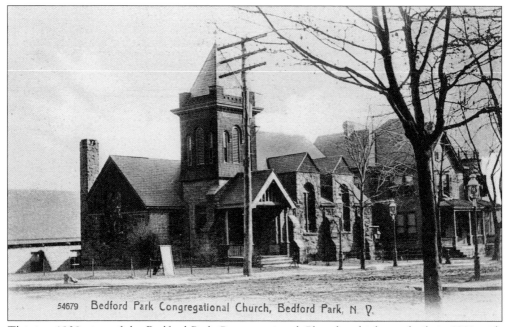

54679 Bedford Park Congregational Church, Bedford Park, N. Y.

This is a 1909 view of the Bedford Park Congregational Church, which was built in 1891 with Edgar K. Bourne as architect. It is located at 2988 Bainbridge Avenue at 201st Street. The church was founded by Sherjashub Bourne, the architect's father. The New York City landmark church was the first major social institution for the planned Bedford Park suburban community.

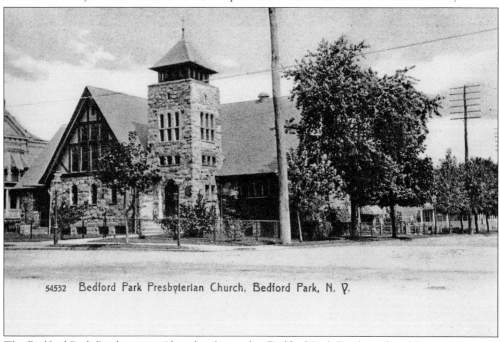

54532 Bedford Park Presbyterian Church, Bedford Park, N. Y.

The Bedford Park Presbyterian Church is located at Bedford Park Boulevard and East 201st Street and was constructed in 1900 as designed by architect Robert H. Robertson. Many homes in the neighborhood are Victorian and Queen Anne style, which complements the granite and wood Tudor church. The church serves many local Korean parishioners.

Three

WOODLAWN

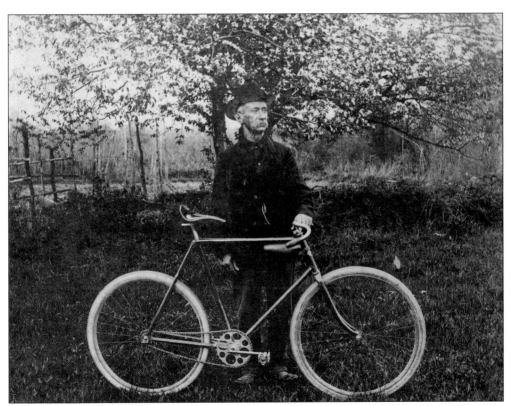

This photograph shows John Shannon, a foreman at Woodlawn Cemetery in the early 1900s. He lived on Jerome Avenue halfway between the end of the subway line and East 233rd Street. (Courtesy of the John McNamara collection.)

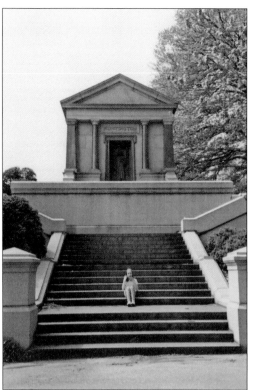

This is a 1997 photograph of Erin Twomey at the Collis P. Huntington monument in Woodlawn Cemetery. Huntington, the railroad magnate, had a palatial home on Schurz Avenue in Throggs Neck, which still stands and is now known as Preston High School. The mausoleum was designed by architect Robert Caterson and took five years to build.

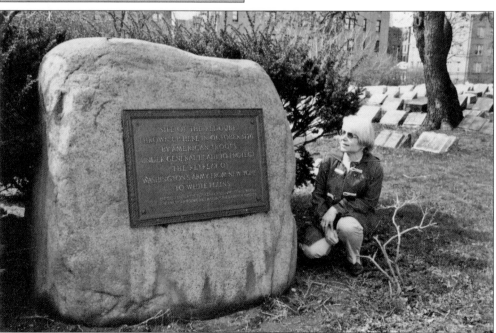

This stone marker in the Heliotrope section of Woodlawn Cemetery marks the site of a Revolutionary War redoubt. The small fort saw action on January 25, 1777, when General Heath took refuge there while being pursued by the British. His men fired two canon volleys, and the British retreated to Fort Independence.

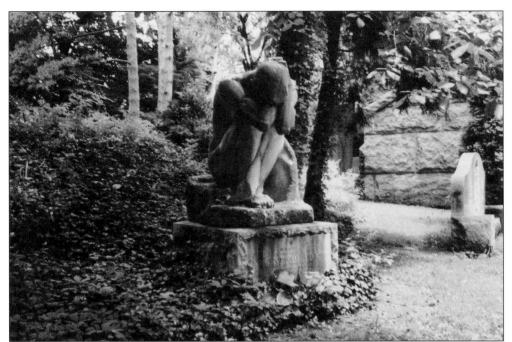

Attilio Piccirilli sculpted this statue called *Outcast*, which was the recipient of the gold medal at the Panama-Pacific International Exposition in 1915. It marks the grave site of Nathan Piccirilli, Attilio's nephew, who was a casualty of World War II in 1944. It is located in the Myosotis section of Woodlawn Cemetery.

Rare would be the Bronxite who has not shopped at a Macy's department store. The Macy monument is located on Beech Avenue in the Crown Grove section of Woodlawn Cemetery. Roland H. Macy, the founder of the department store chain, passed away in 1877, but his legacy lingers on with the myriad of shoppers who still frequent his stores.

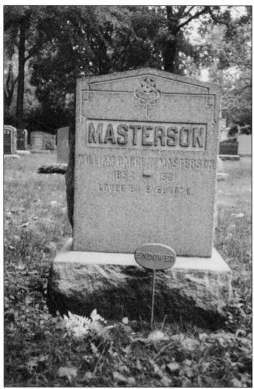

This is a 1993 photograph of "Bat" Masterson's grave site at the historic 400-acre Woodlawn Cemetery. The simple stone, located in the Primrose Section, is inscribed: "William Barclay Masterson, 1854–1921, loved by everyone." When Masterson came east to New York, he became a sports writer for the *Morning Telegraph*. His birth year on the stone is in error as he was actually born on November 26, 1853.

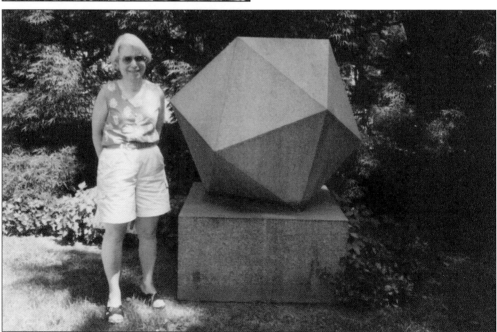

The Nimmo monument, located in the Holly section of Woodlawn Cemetery, was crafted by Joseph Havender Sr. in his Jerome Avenue shop. Carol Twomey is standing next to the stone, which was carved with 20 sides with each surface forming an equilateral triangle. The resulting formation is called an icosahedron. The Nimmos are part of the Oscar Hammerstein family.

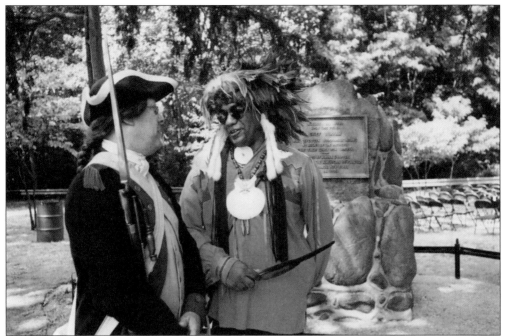

On August 31, 1778, during the American Revolution, Chief Nimham and 17 Stockbridge Indians, who were scouts and soldiers of the patriots, gave their lives for liberty in a battle in the Woodlawn-Van Cortlandt Park area now known as Indian Field. The monument was erected on June 14, 1906, by the Bronx Chapter of the Daughters of the American Revolution and rededicated and reinforced in 2001.

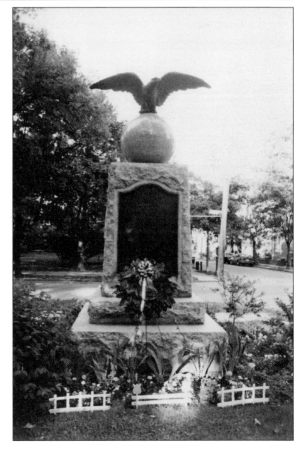

The *Woodlawn War Memorial Monument* is located at Van Cortlandt Park East and Oneida Avenue. Van Cortlandt Park East was once part of the 1776 Mile Square Road. The memorial was donated by the Woodlawn Taxpayers and Community Association and was dedicated on July 4, 1925. The ball was fashioned from Stony Creek granite, and the eagle is bronze.

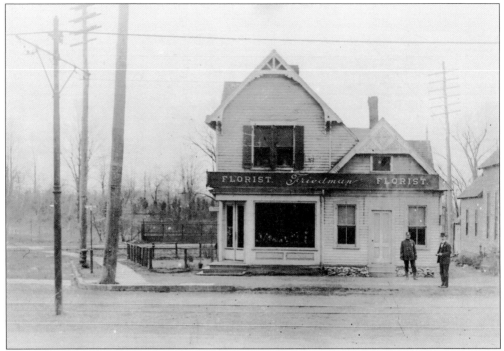

This photograph of the Friedman Florist on Jerome Avenue was taken in 1890, and the photographer was looking east toward Woodlawn Cemetery. This became the end of the Woodlawn-Jerome line of the IRT. The man at the left is a police officer in uniform, and the building at the right is the Havender Monument Works. (Courtesy of the John McNamara collection.)

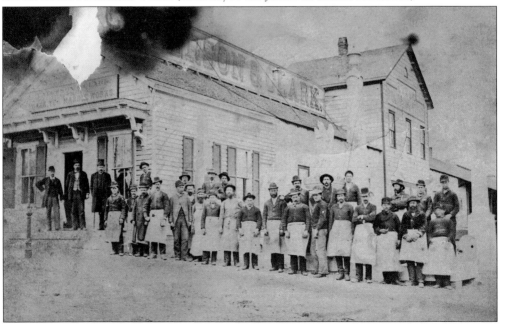

Employees of Caterson and Clark, stonecutters, are standing outside the facility on 233rd Street at Vireo Avenue opposite Woodlawn Cemetery around 1885. The building was torn down around 1960. (Courtesy of the John McNamara collection.)

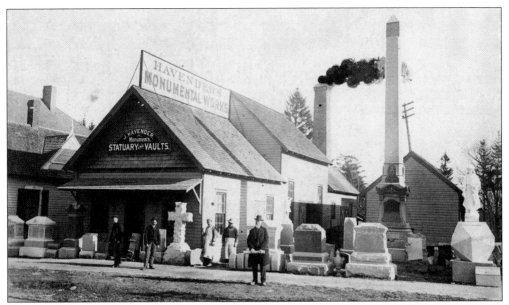

This photograph of Havender's Monumental Works was taken around 1903 at their plant located at 3686 Jerome Avenue across the street from Woodlawn Cemetery. The business was founded in 1895 by Joseph Havender Sr. He passed away in 1952, and the firm passed to his son, Joseph Jr. The man in the center foreground in the street is Mike Baily. Note the 20-sided stone called an icosahedron at the extreme right, which is considered a masterpiece by stonecutters. (Courtesy of the John McNamara collection.)

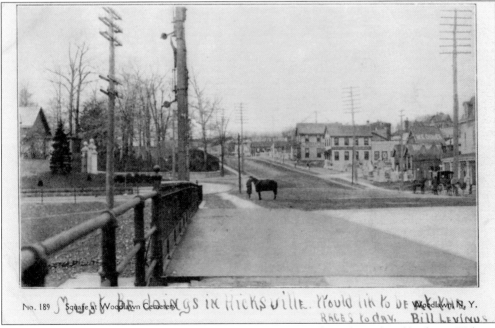

This is a 1907 postcard view of East 233rd Street looking west from the railroad bridge at Webster Avenue. The gates to the entrance of Woodlawn Cemetery are on the left. Stonecutters such as Caterson's and Samuel Cockburn and Sons line the north side of East 233rd Street. A gas station has replaced the rest stop for the horse-drawn carriages and thirsty patrons.

The Woodlawn Heights Presbyterian Church was built in 1913 and dedicated on May 10, 1914. Their budding congregation had previously met at Hopewell Hall on 240th Street, east of Martha Avenue. The church is located at the northeast corner of 240th Street and Martha Avenue.

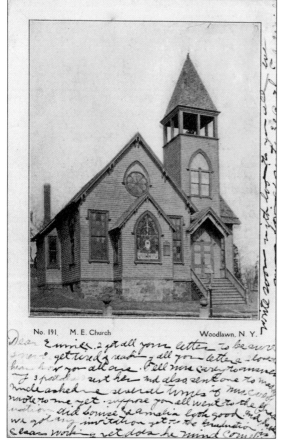

No. 191. M. E. Church Woodlawn, N. Y.

This photograph shows the original Methodist Episcopal Church of Woodlawn Heights. It was established in 1875 on 237th Street between Katonah and Kepler Avenues, and the church was dedicated on Easter Sunday of 1876. They moved to 241st Street and Katonah Avenue in 1913. The old building, shown here, was razed in the 1920s. The name was officially changed to St. Luke's Methodist Episcopal Church in 1934, and the term Episcopal was deleted in 1939. It then became known simply as St. Luke's United Methodist Church.

Joe Sturm plied the streets of Woodlawn with his horse and wagon from 1891 to 1902. Housewives listened for the familiar sound of his voice calling out as he pulled up to the curb with his cart of fresh fruit and vegetables. This portrait, taken by W.A. Robinson, shows Sturm with his wife. (Courtesy of the John McNamara collection.)

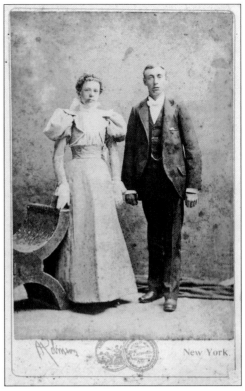

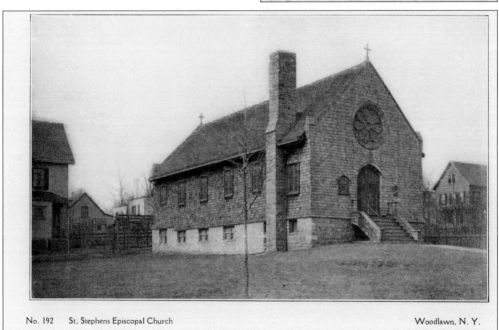

No. 192 St. Stephens Episcopal Church Woodlawn, N. Y.

St. Stephen's Episcopal Church was established on Sunday, May 23, 1897, in a storefront located at Webster Avenue and 234th Street. It moved to 228 East 238th Street in 1898, and the following year they obtained the property at 439 East 238th Street where they laid the cornerstone to their new church in 1900. The church was officially consecrated into the diocese in 1945.

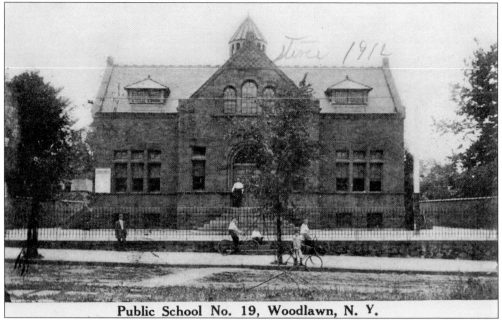

Public School No. 19, Woodlawn, N. Y.

P.S. 19 on East 234th Street was designed by architect Charles B.J. Snyder and was built in 1893. The old P.S. 19 then served as an annex for Evander Childs High School until 1939. The postmark on this postcard bears the date August 30, 1912, and it was mailed from Williams Bridge, New York. P.S. 19 was also known as the Edward Eggleston School after the novelist.

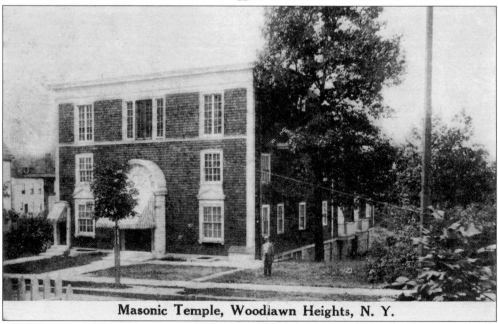

Masonic Temple, Woodlawn Heights, N. Y.

This is a 1915 postcard view of the Masonic Temple, known as Varian Hall, located on Katonah Avenue. The residents of Woodlawn complained that they needed a new school as P.S. 19, built in 1893 and located on East 234th Street, could not support the growing student population. Varian Hall was moved, and the property was used for the current P.S. 19 that opened in 1925 and was renamed the Judith K. Weiss School.

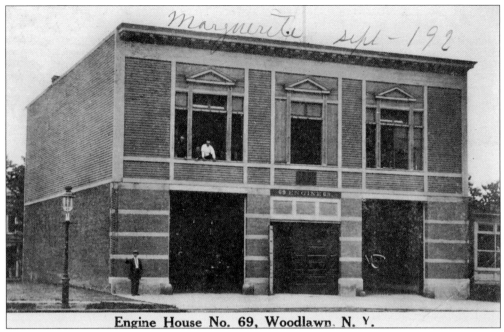

Engine House No. 69, Woodlawn, N. Y.

The firehouse in Woodlawn was established on July 1, 1899. Although it once housed only Engine No. 69, it later also became home to Ladder Company 39. It was located at 243 East 233rd Street just south of the junction of East 234th Street at Van Cortlandt Park East. It closed down in 2007 and the station was moved to Engine 63 in Wakefield approximately one mile away.

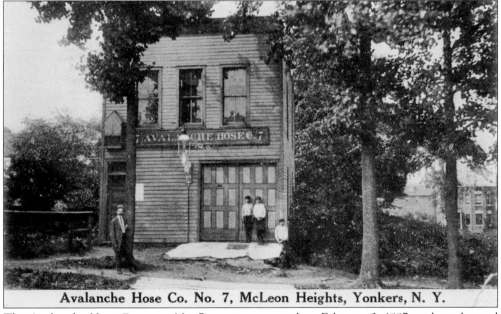

Avalanche Hose Co. No. 7, McLeon Heights, Yonkers, N. Y.

The Avalanche Hose Company No. 7 was incorporated on February 2, 1897, and was located on the southeast side of East 240th Street at Webster Avenue. The volunteer fire company was probably in service before incorporation covering Woodlawn and southern Yonkers. The Edgewater Park Volunteer Hose Company No. 1 is now the only active volunteer fire company in the east Bronx.

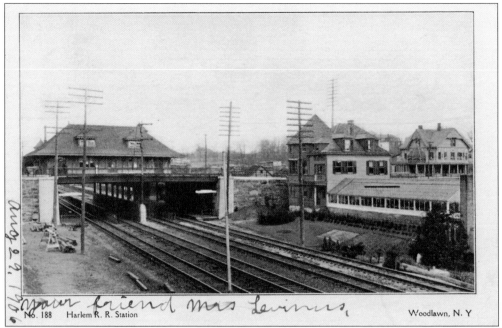

No. 188 Harlem R. R. Station Woodlawn, N. Y

This postcard of the Harlem River Railroad Station at Woodlawn is postmarked August 30, 1906. The photographer was looking east from Webster Avenue just south of East 233rd Street. Note Oetjen's Restaurant in the right background. It was located just east of the railroad at 591 East 233rd Street and closed in October 1949 after being condemned for the widening of the Bronx River Parkway. Mayer's Parkway Restaurant, next door, acquired many of their patrons. Oetjen's later reopened in Westchester County.

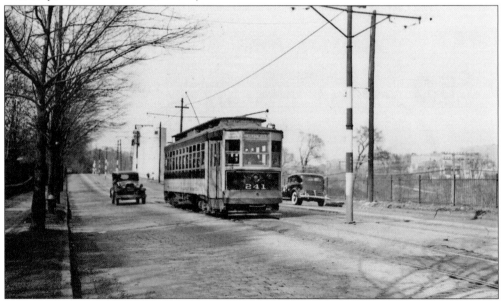

This convertible streetcar carries number 241 (Brill, 1911) and is traveling south on Webster Avenue on April 20, 1935. This is a shuttle line that operated between Fordham Square and the city line at McLean Avenue in Yonkers until the line's abandonment on August 18, 1935. Woodlawn Cemetery is on the left. (Courtesy of the Bill Armstrong collection.)

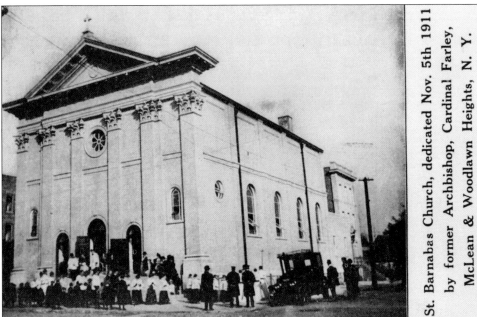

This postcard was issued to commemorate the dedication of St. Barnabas Church. The printing at the right of the card reads: "St. Barnabas Church, dedicated Nov. 5th, 1911 by former Archbishop, Cardinal Farley, McLean & Woodlawn Heights, N. Y." It should be noted that John Farley was still an archbishop on November 5, as he was not incardinated until November 27, 1911.

ST. BARNABAS CHAPEL — GYMNASIUM & CONVENT, McLEAN AVE. CORNER 241ST ST.
RT. REV. MSGR. GEORGE H. McWEENEY, PASTOR STARRETT & VANVLECK, ARCHITECTS

St. Barnabas Parish was established by Archbishop John Farley on June 11, 1910. Their elementary school opened in February 1913 in the basement of the church. The new school building at 409 East 241st Street opened in 1915. The first high school opened in September 1924, and classes at the new high school began in April 1959. Monsignor Edward Barry is the current pastor of the parish.

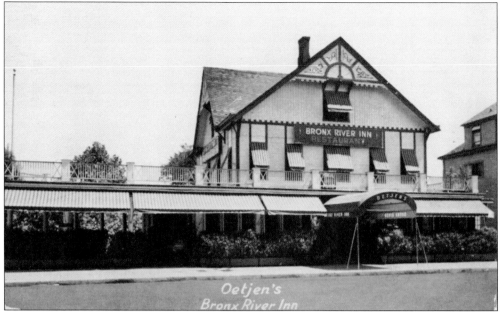

Oejten's Restaurant was located at 591 East 233rd Street east of the New York Central Railroad's Woodlawn station and began service to the community as the Bronx River Inn. The Bronx River Parkway was expanded from two to six lanes around 1952, and the restaurant was condemned and razed in 1949 in preparation for the expansion. Oejten's relocated and lasted for 10 more years on Boston Post Road in lower Westchester County.

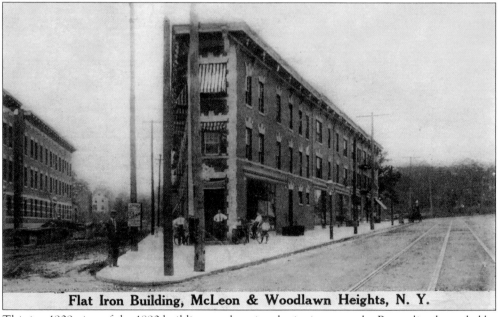

Flat Iron Building, McLeon & Woodlawn Heights, N. Y.

This is a 1909 view of the 1890 building on the triangle site just over the Bronx line bounded by McLean Avenue on the right, St. Barnabas Place on the left, and Martha Avenue to the north. Levine's Ice Cream Parlor at the corner is now William Palmer's Paint Store. Merk Chemists, with an extended awning on the right at 973 McLean Avenue, still anchors the building and has been there since 1896.

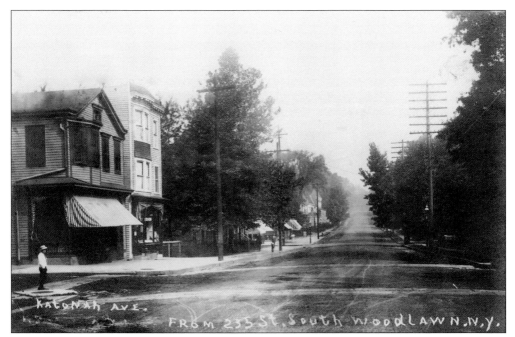

This is a 1920 postcard view of Katonah Avenue looking north from East 235th Street. The frame building on the corner of 235th Street was known as Smith's General Store. The store, which is now a food shop, is considered by local historians to be one of oldest stores in Woodlawn. (Courtesy of Robert Stonehill.)

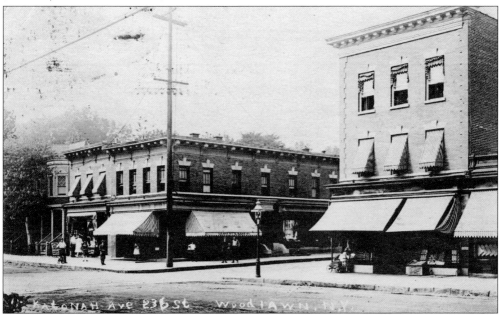

This is a 1920 postcard view of Katonah Avenue at East 236th Street during a summer month. The two brick buildings on the south corner of East 236th Street and the three- story brick building on the north corner form the central shopping area of Woodlawn in 1920, as well as in 2010. The use of roll-up awnings to cover windows from the searing sun was popular in the era before air-conditioning. (Courtesy of Robert Stonehill.)

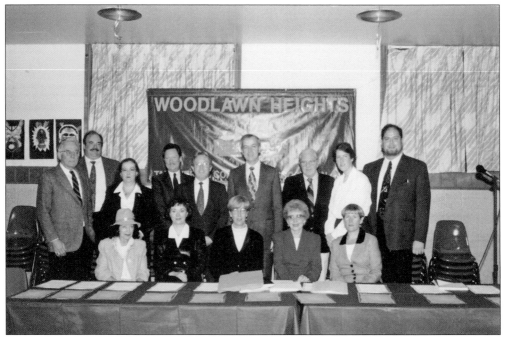

The Woodlawn Heights Taxpayers and Community Association, Inc., was established in 1895. This group poses after their 1997 swearing in ceremony. Brian Anderson, the New York City Municipal Archives commissioner, is the fourth from the left among those standing in this photograph.

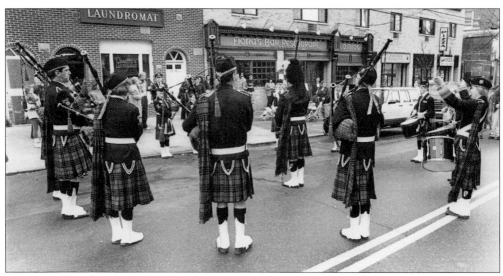

St. Brigid's Pipe Band was established in 1949 and is still the pride of County Leitrim. They are performing here on Katonah Avenue and East 239th Street. This area is an Irish enclave, and the marchers from Kiltubrid came over to march in the popular Woodlawn parade. The laundromat is now home to Tunnel Workers Local 147.

Four

KINGSBRIDGE/
SPUYTEN DUYVIL

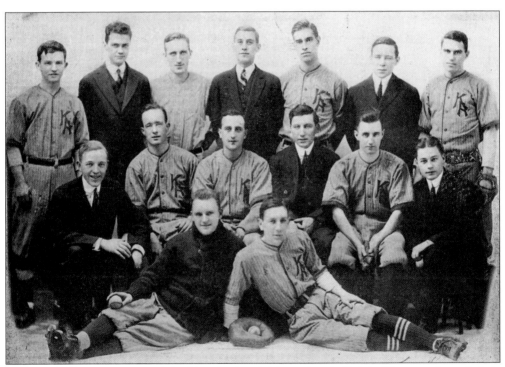

This is a 1914 team picture of the Kingsbridge Athletics baseball club. The team hosted their Grand Annual Ball on Friday evening, January 30, 1914, at the Manhattan Casino, located at 155th Street and Eighth Avenue in New York City. Music was provided by Professor Lauerman and featured 24 numbers, including "You're Rocking the Boat," "Ragtime Arabian Knights," and "Good Ship Mary Ann."

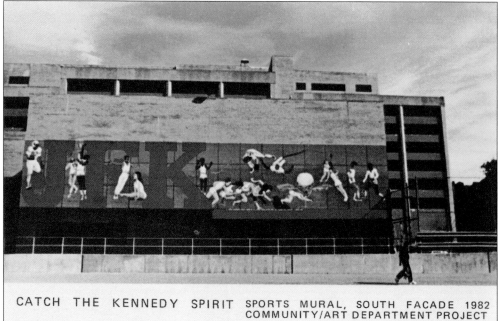

CATCH THE KENNEDY SPIRIT SPORTS MURAL, SOUTH FACADE 1982 COMMUNITY/ART DEPARTMENT PROJECT

Public School No. 7, Kings Bridge, N. Y.
HAS. H. BUCK

John F. Kennedy was a Riverdale resident in his boyhood, and it was appropriate that the first public high school in the Riverdale/Spuyten Duyvil/Kingsbridge community would be named for President Kennedy in 1972. JFK High School is part of a five-school campus built on the old New York Central train yards. The 1982 mural used to face the tennis courts, football, and baseball fields before being removed.

This is a 1906 Charles Buck postcard of P.S. 7, which opened in 1895 at West 232nd Street and Church Street (Kingsbridge Avenue). West 232nd Street was not cut through to Kingsbridge Avenue until 1928. The four-story brick building was designed by architect Charles B.J. Snyder and was originally Grammar School 66 before being renumbered P.S. 7 in 1903. The school was razed in 1965.

This postcard image shows the original Church of the Mediator in Spuyten Duyvil, which was incorporated on August 15, 1855. In 1908, a stone and mortar structure replaced the frame building, and the first service in the new church was held in 1913. Debt service was finally paid off in 1927, when it was officially consecrated by Bishop William T. Manning. It is located at 260 West 231st Street.

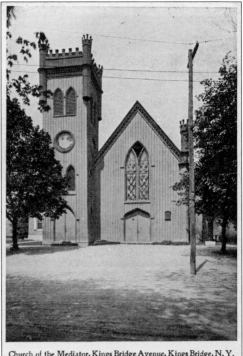

Church of the Mediator, Kings Bridge Avenue, Kings Bridge, N. Y.
CHAS. H. BUCK, KINGS BRIDGE, N. Y.

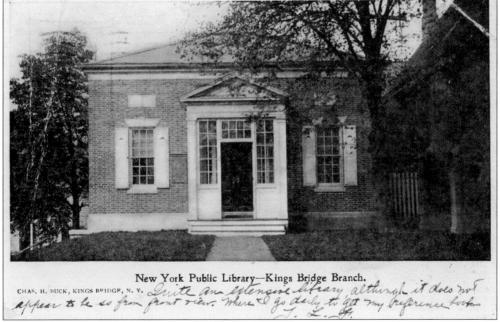

New York Public Library—Kings Bridge Branch.
CHAS. H. BUCK, KINGS BRIDGE, N. Y.

This postcard of the Kingsbridge Branch of the New York Public Library is postmarked September 17, 1906. Construction of the building began in April of 1904, and the cost was $20,000, which was supplied by an Andrew Carnegie grant. It opened on May 19, 1905, and the address was 3041 Kingsbridge Avenue. Today it is used to provide child care and nursery services.

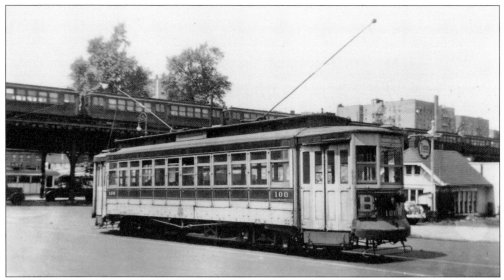

This convertible streetcar (trolley) bears the number 100 (Brill, 1909) and is at its western terminus at 230th Street and Broadway. It is on the B-Bailey Avenue line, which operated between this location and Fordham Square on a stub track beneath the Third Avenue elevated line. Both of the trolley poles are up on the wire, showing that the procedure called "changing ends" is taking place. The trailing pole will be pulled down, while the front pole is raised to come in contact with the overhead power line. The motorman will then move the fare box from one end to the other, reverse the seats, and move the reverser key from one controller to the other before admitting passengers. (Courtesy of Bill Armstrong.)

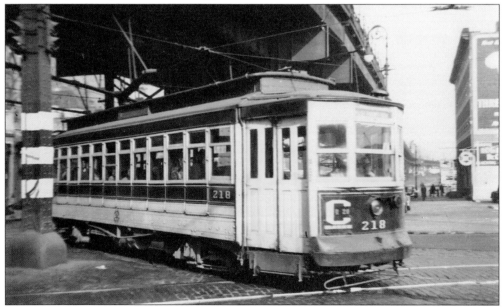

This convertible streetcar number 218 (Brill, 1911), on the C-Bronx and Van Cortlandt Parks line, is just turning off Broadway onto West 225th Street en route to its eastern terminus at West Farms on October 12, 1946. The elevated line overhead is the original Interborough subway that opened to 145th Street on October 27, 1904, and reached this point on November 14, 1907. (Courtesy of Bill Armstrong.)

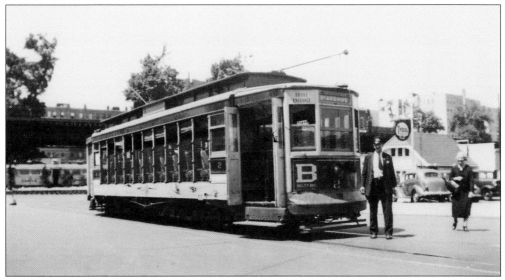

The first thing one notices about this streetcar is that the open mesh screens have replaced the glass windows, indicating the arrival of summer. This is a convertible bearing the number two, and it is at the western terminus of the B-Bailey Avenue line at 230th Street and Broadway. The motorman has already reversed the poles, and the car is ready to return to its eastern terminus at Fordham Square. (Courtesy of Bill Armstrong.)

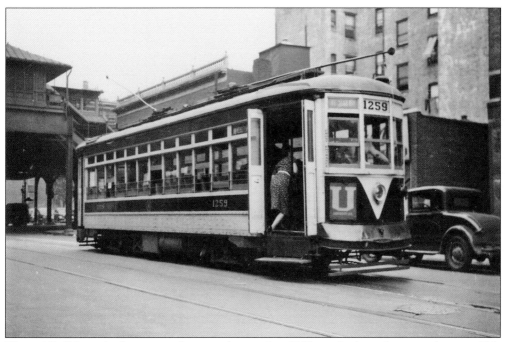

This oddball homebuilt streetcar bearing the number 1259 was built in the main shops at 65th Street and Third Avenue in Manhattan and was used on the U-University Avenue line on 238th Street and Broadway in 1940. The 238th Street station of the original Interborough subway is in the background. (Courtesy of Bill Armstrong.)

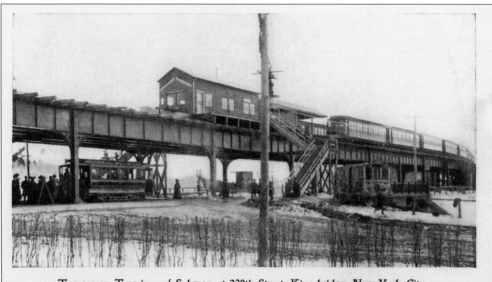

Temporary Terminus of Subway at 230th Street, Kingsbridge, New York City.

CHAS. H. BUCK, KINGS BRIDGE, N. Y.

Charles H. Buck captured the center of transportation activity in Kingsbridge at Broadway and West 230th Street in 1907. The subway did not reach West 242nd Street yet, and this was the temporary terminus of the Broadway line. A trolley and horse carriage is loading passengers to continue north, as the subway above is headed south.

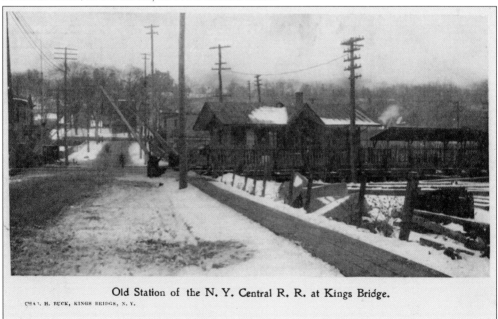

Old Station of the N. Y. Central R. R. at Kings Bridge.

CHAS. H. BUCK, KINGS BRIDGE, N. Y.

This is a 1907 view of the Kingsbridge Station at West 230th Street looking east to Bailey Avenue and up the hill to the houses on Sedgwick Avenue that lined the Jerome Park Reservoir. The old station of the New York Central Railroad line was later constructed below grade to avoid car and pedestrian traffic. Charles H. Buck had his drugstore and postcard shop in Parsons Hall at Broadway and West 233rd Street.

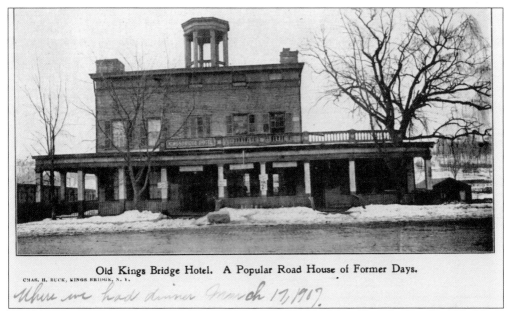

Old Kings Bridge Hotel. A Popular Road House of Former Days.

Where we had dinner March 17, 1907.

The Kings Bridge Hotel was located on the east side of Kingsbridge Road north of today's 225th Street. It dated back to the mid-19th century and was a popular vacation site as early as the 1880s. The wood-frame building was two and a half stories in height with an imposing cupola, as seen in this photograph. The handwritten wording at the bottom of the card reads: "Where we had dinner March 17, 1907." Note the large stone block at the right of the entryway, which was used to dismount from a horse, the common mode of transportation of the day.

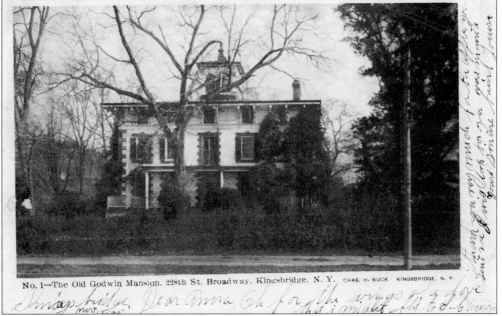

No. 1—The Old Godwin Mansion. 228th St. Broadway. Kingsbridge. N. Y. CHAS. H. BUCK KINGSBRIDGE, N. Y.

The Godwin Mansion was formerly known as the Macomb Mansion, which was located at the northwest corner of 230th Street and Broadway. Constructed by Gen. Alexander Macomb, it was sold to Joseph H. Godwin in 1848. Godwin enlarged it somewhat, and it stood beneath three huge and glorious elm trees until it was razed around 1919.

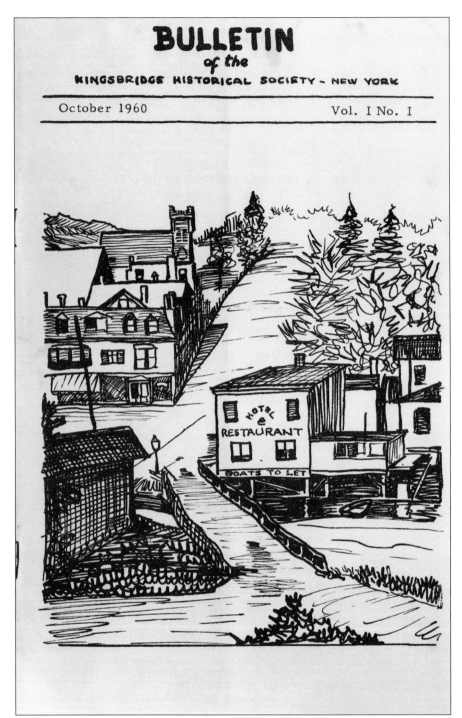

BULLETIN
of the
KINGSBRIDGE HISTORICAL SOCIETY - NEW YORK

October 1960 Vol. I No. I

HOTEL & RESTAURANT

BOATS TO LET

This is volume 1, issue 1 of the *Bulletin of the Kingsbridge Historical Society* and is dated October 1960. The cover features a drawing of Kingsbridge around 1900, drawn from a photograph of that era. The society was founded in 1949, and Rev. William A. Tieck, Ph.D., served as the president when this bulletin was prepared. Peter Ostrander currently serves as president, and Marianne Anderson is vice president.

RIVERDALE AVE., KINGSBRIDGE, N. Y., *June 26* 1895

M̲r̲ Fire Dep't of City of New York

To P. MALONE, Dr.

HORSE SHOEING ESTABLISHMENT.

Particular attention paid to Gentlemen's Road Horses.

Dr. Roberge's Patent Hoof Expanders Applied.

WAGON REPAIRING IN ALL ITS BRANCHES.
WAGONS FOR SALE.

Horse Shoeing for the Month of June 1895

Engine Co No 52

June 21	1 Horse	✓	3,00
24	4 Horses	✓	12,00
25	2 Horses	✓	6,00
26	1 Horse	✓	3,00
		$	24,00 ✓

J. Forrest
J. Hamilton J. Purdy
Foremen

The horseshoe establishment of Patrick Malone, located at Riverdale Avenue at West 230th Street in Kingsbridge, New York, sent out their June 1895 invoice of $24 for eight horses shod. The bill was to the fire department of the City of New York, Engine Company Number 52. The invoice notes that wagons are for sale, and Dr. Roberge's patent hoof expanders are used.

This is a 1908 postcard of St. Stephen's Methodist Church in Marble Hill, which overlooked the site of the old Kings Bridge. It is located on West 228th Street overlooking Rev. William Tieck Way. The good reverend was pastor of St. Stephen's and also served as the official Bronx historian. Historical renovations to the building in 2010 carefully match the original details, especially above the entryways.

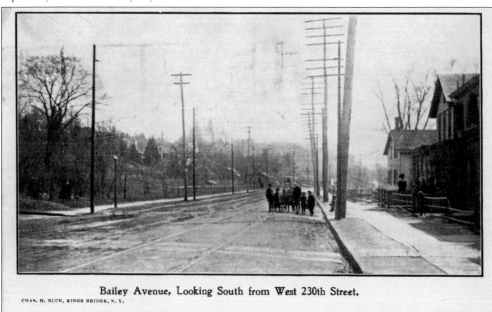

This 1907 view of Bailey Avenue, looking south from 230th Street, shows a family in front of their home on the west side of Bailey avenue, now the Major Deegan Expressway. Two-story single family row houses that still survive were built on the empty lot. The Roman Catholic Orphan Asylum is faintly visible on the hill in the center of this image.

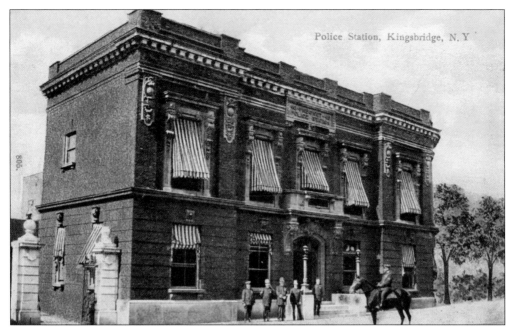

The Kingsbridge Heights Police Station was originally the 40th Precinct and was later designated as the 50th. Designed by architects Arthur J. Horgan and Vincent J. Slattery, it was built in 1902. Located at Kingsbridge Terrace and Summit Place west of the Jerome Park Reservoir, the station was designated a New York City landmark in 1986. In 1974, the Kingsbridge Heights Community Center transformed the neglected structure to a vital neighborhood resource serving youth and adult programs.

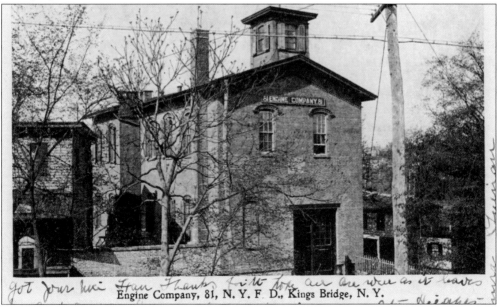

This is a 1906 Charles Buck postcard of the New York Fire Department Engine Company 81 in Kingsbridge, New York. The two-story brick structure was constructed in 1872 and housed the old Kingsbridge School until 1895 when it became a firehouse. Engine Company 81 stood on Albany Crescent and West 230th Street, a short distance behind the present firehouse.

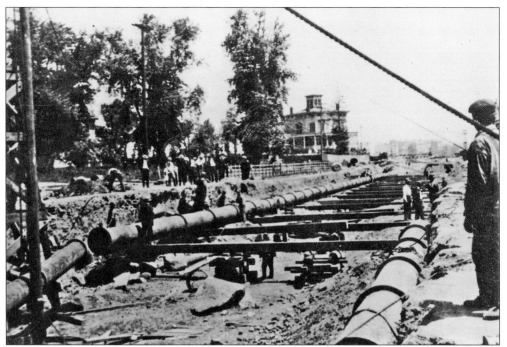

This 1915 photograph shows Kingsbridge Creek being filled in and utility pipes being installed. The Godwin Mansion is in the left background and was located on the north side of West 230th Street. The photographer was looking from Kingsbridge Avenue east toward Broadway. The mansion was razed around 1919. (Courtesy of the John McNamara collection.)

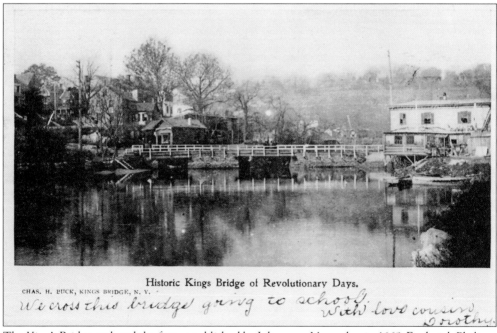

Historic Kings Bridge of Revolutionary Days.

CHAS. H. BUCK, KINGS BRIDGE, N. Y.

We cross this bridge going to school.
With love cousin
Dorothy.

The King's Bridge replaced the ferry established by Johanases Verveelen in 1669. Frederick Philipse built the King's Bridge in 1693, and it remained in operation until after the Revolutionary War. Locals were not happy about paying a toll to cross it, which led to many disputes with authorities.

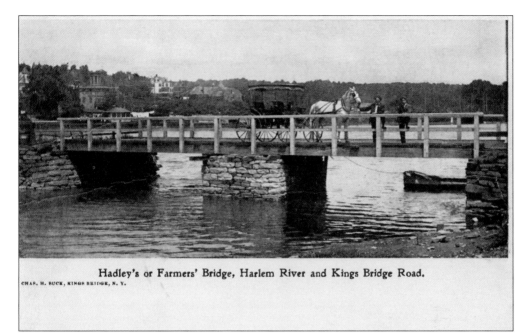

Hadley's or Farmers' Bridge, Harlem River and Kings Bridge Road.

The Farmer's Bridge, also known as the Free Bridge, was opened in 1758 at today's 225th Street east of Broadway. It was also called the Hadley Bridge after the family whose homestead later took the address 5122 Post Road. The Free Bridge was built to bypass the King's Bridge, which charged a toll to cross.

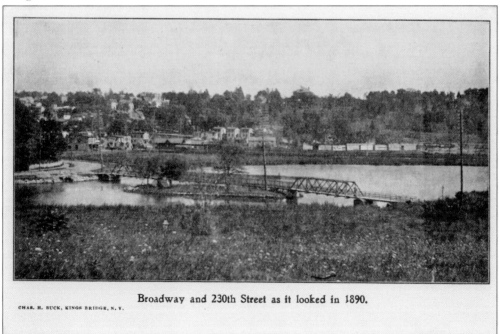

Broadway and 230th Street as it looked in 1890.

This is a 1907 Charles H. Buck postcard view of Broadway and West 230th Street as seen from Marble Hill looking east to Kingsbridge Heights. Houses and billboards line Exterior Street along the Harlem and Putnam Railroad line. The island under the bridge was known as Godwin's Island, with the Godwin Mansion at the turn of the road on the left.

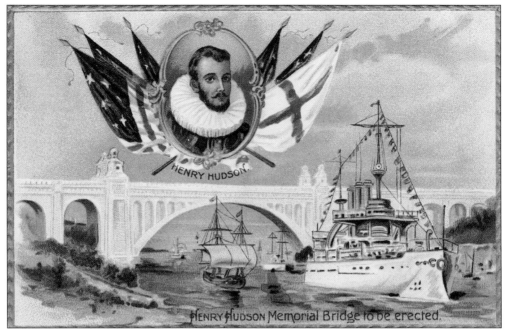

In 1909, to commemorate the 300th anniversary of Henry Hudson's discovery of the Hudson River, a memorial bridge of reinforced concrete was conceived. The bridge was to cross the Spuyten Duyvil Creek connecting Inwood Hill at the south to Spuyten Duyvil in the Bronx. Fearful of losing their bucolic lifestyle, Riverdale and Inwood residents opposed the building of the bridge. Robert Moses had other ideas and on December 12, 1936, a 2,208-foot steel arch bridge opened to traffic, but the bridge shown here was never built.

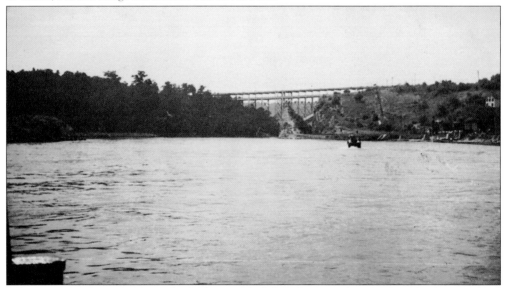

The Henry Hudson Bridge in the background of this photograph was once the longest fixed steel arch bridge in the world. This 1948 view is to the west on the Harlem River and was photographed by John McNamara from his canoe. Spuyten Duyvil at Johnson Avenue and Johnson's Foundry is to the right, and Inwood Park in Manhattan is at the left. (Courtesy of the John McNamara collection.)

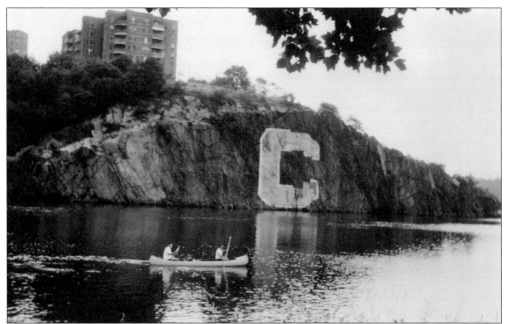

Ronald Schliessman is at the stern, and John McNamara is at the bow as they paddle past the Big C in 1963. The view across the Harlem River is from Inwood north toward Spuyten Duyvil. The Big C is known as Columbia Rock and is alleged to have been painted by Columbia University engineering students. The C is 60 feet in height and visible from the Hudson River. (Courtesy of the John McNamara collection.)

This photograph of the Spuyten Duyvil station of Metro North's Hudson Line appears to have been taken from the Henry Hudson Bridge pedestrian walkway. The Palisades in New Jersey across the Hudson River form the backdrop of this great scene. A leg of the west to east wye track between the freight line and the Hudson line veers to the left in this photograph. The waterway at left is the Harlem Ship Canal.

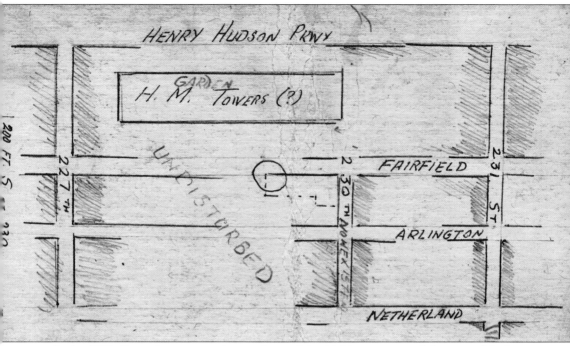

In the 1960s, Bronx historian, author, and artist John McNamara penned this map of the location of Fort Number Two. McNamara indicates that Fort Number Two, located on Spuyten Duyvil hill (Tippett's Hill), was 200 feet south of West 230th Street and 230 feet west of Arlington Avenue. The building labeled H.M. Towers is now Hudson Gardens, located at 2728 Henry Hudson Parkway East. The fort was built by Col. Abraham Swartwout in 1776 and named for him, but the British renamed it Fort Number Two after they took occupation. (Courtesy of the John McNamara collection.)

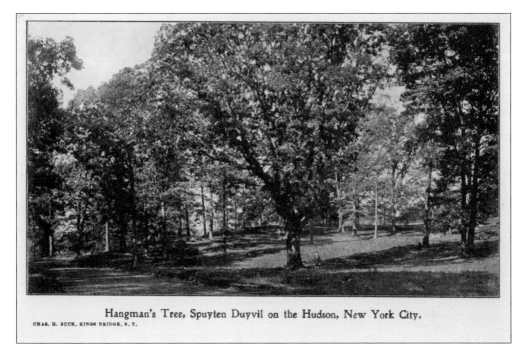

This is a 1906 Charles Buck postcard of the Hangman's Tree at Spuyten Duyvil, which was located west of Riverdale Avenue and north of West 236th Street. In 1913, the Cowboy Oak trunk measured 13 feet. During the American Revolution, tradition records that British loyalists named Cowboys raided local farmers, and when caught by the farmers, they were swiftly punished by hanging.

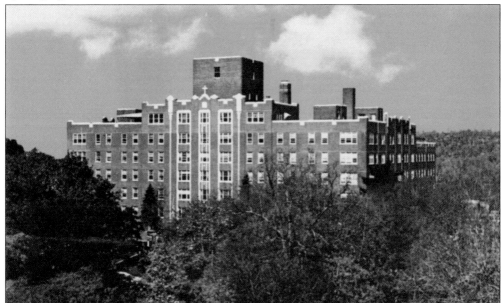

This is a 1950 view of the Frances Schervier Home and Hospital located on 12 acres at West 227th Street and Independence Avenue overlooking Henry Hudson Memorial Park. Since 1938, the Franciscan Sisters of the Poor provided care and nursing services here. The home is located on the site of Fort Number One, which was constructed in 1776 during the American Revolution.

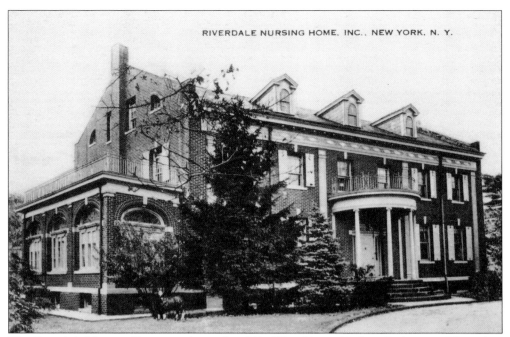

The Riverdale Nursing Home was located at 3031 West Henry Hudson Parkway at West 231st Street. The home selected the Spuyten Duyvil location to "take advantage of the country within the convenience of the City." There are now 22 three-story townhouses surrounding the former courtyard.

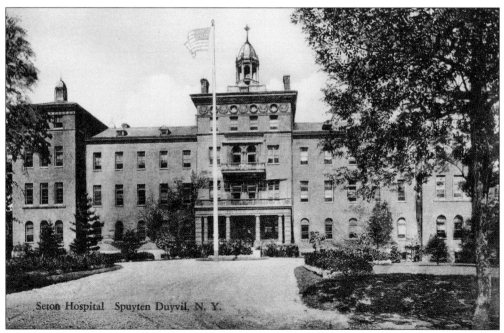

Seton Hospital Spuyten Duyvil, N. Y.

Seton Hospital opened in 1894 and is viewed from the west side of the Henry Hudson Parkway between West 232nd and West 235th Streets in 1950. In 1960, New York City sold three acres, and the Whitehall high-rise was erected. The 25-acre balance is now Seton Park.

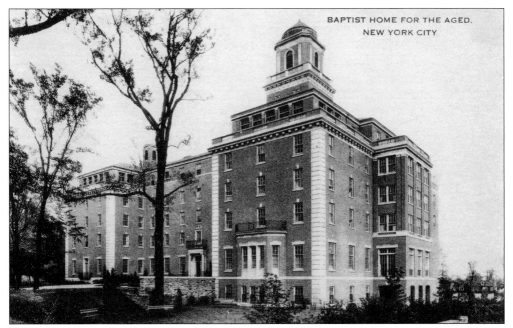

The Baptist Home for the Aged was located at West 235th Street, Arlington Avenue, and East Henry Hudson Parkway. Built in 1929 at a cost of $750,000, the five-story brick home by architect Augustus N. Allen accommodated 140 residents. In 2006, a seven-story condominium was built, and Columbia University purchased the building in 2008 to house faculty and students.

This is a 1915 advertising postcard for "Crestmont, a modern Health resort for care of invalids and convalescents seeking rest and health" in Spuyten Duyvil. Dr. Caroline F.J. Rickards was the physician in charge. When Dr. Rickards passed away in 1954 at age 81, she was the oldest practicing female physician in the United States.

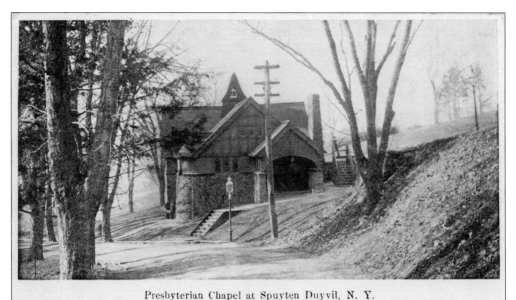

Presbyterian Chapel at Spuyten Duyvil, N. Y.

CHAS. H. BUCK

This is a 1903 Charles H. Buck postcard looking west to the entrance and doorway of the Presbyterian Chapel at Spuyten Duyvil. The chapel is known as Edgehill Church. Architect Francis Kimball designed the Tudor-style church in 1888. Oddly, the road passing the lower steps and the road above the upper steps are both named Independence Avenue.

This is a 1935 postcard view of the Augustinian monastery located at 3103 Arlington Avenue at West 231st Street. A number of the Augustinian missionaries are lining the soon-to-be cut through West 231st Street. The Augustinians of the Mother of Consolation Monastery have expanded their residence toward the left twofold since 1935.

Local architect Dwight James Baum designed the Riverdale War Memorial, located at 239th Street and Riverdale Avenue. It weighs over 500 tons yet was moved 700 feet south in 1936 when the Henry Hudson Parkway was laid out. The tower bell was cast in Spain for a Mexican monastery in 1762. It was brought to New York in 1846 and hung in the Jefferson Market in Greenwich Village, and it was used at Engine Company 52 in Riverdale in 1884.

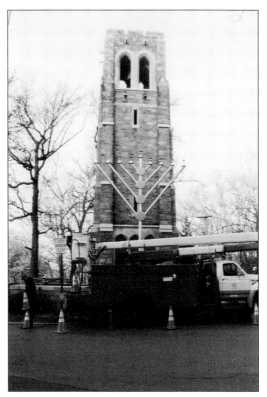

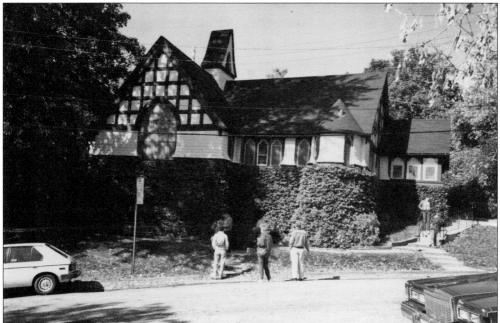

This photograph of the Edgehill Church located at 2570 Independence Avenue was taken by Bill Twomey on October 20, 1991. It was built by architect Francis H. Kimball on land donated by Mary E. Cox in 1888–1889 and is noted for its Tiffany stained glass windows. Former Bronx historian Rev. William Tieck once served as pastor here. The church was declared a landmark in 1980.

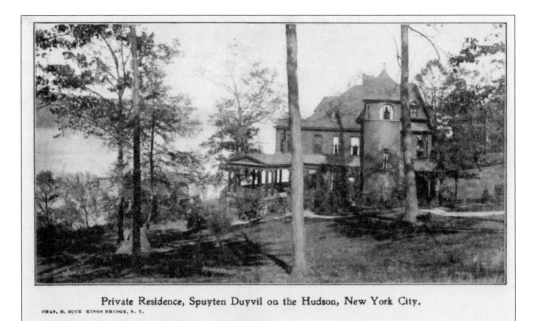

Private Residence, Spuyten Duyvil on the Hudson, New York City.

CHAS. H. BUCK KINGS BRIDGE, N. Y.

This is a 1906 Charles H. Buck postcard view of a private residence at Spuyten Duyvil on the Hudson. The 1880-style Queen Anne Victorian home along Palisades Avenue, with a westerly view to the Hudson River, was replaced by apartment towers after the Henry Hudson Parkway was developed.

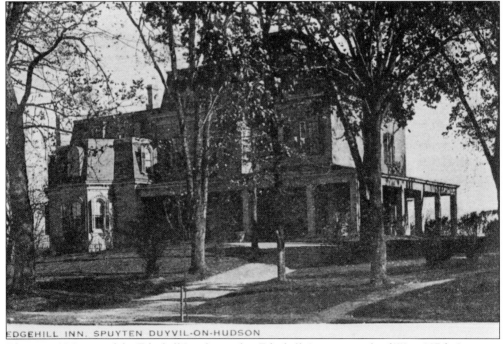

EDGEHILL INN. SPUYTEN DUYVIL-ON-HUDSON

This is a 1906 view of the Edgehill Inn located at Edgehill Avenue north of West 227th Street in Spuyten Duyvil. The former Sage Mansion was constructed before the Civil War and became a well-known inn and wedding banquet hall. In 1912, suites with a private bath were available for $12 per week. The inn closed in December 1952.

Five

RIVERDALE

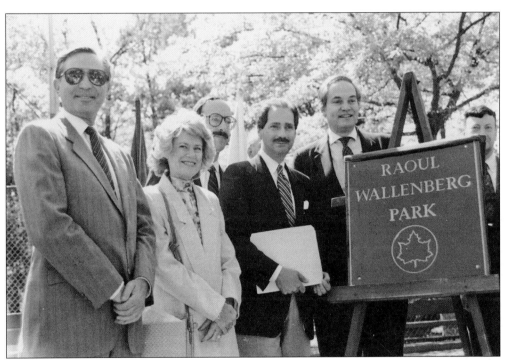

Raoul Wallenberg (1912–1947) was the Swedish diplomat who rescued thousands of Hungarian Jews from the concentration camps during World War II by issuing them Swedish passports. This photograph shows the May 10, 1991, dedication of the park honoring his memory at West 236th Street and Douglas Avenue in Riverdale. It had previously been called Spuyten Duyvil Playground. G. Oliver Koppell was the New York State assemblyman for that district in 1991 and is standing behind and to the right of the sign. Borough president Fernando Ferrer, congressman Eliot Engel, and city council member June Eisland are to the left of the plaque.

Thomas and Sharon Casey pose in front of the artwork titled *Portal*, created by Ed Bisese specifically for Wave Hill. It measures 12 feet by 11 feet by 4 feet and was exhibited in the field to the south of the mansion in 2004.

This building was constructed in 1910 by George Walbridge Perkins, who purchased the estate in 1903. It housed his bowling alley among other amenities. This Bill Twomey photograph shows a piece of the mural on the top of the wall to the right of the bowling lanes. The blackboard shows the innings (frames) for the bowling games. This interior space belowground is not open to the public and is used for storage.

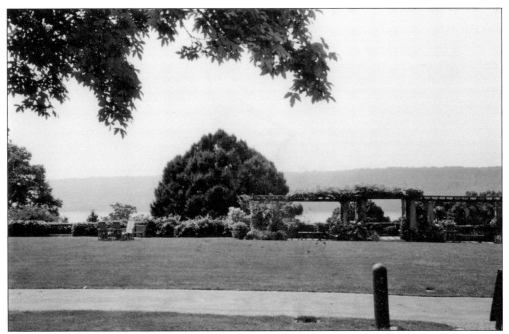

Wave Hill is a 28-acre public garden and cultural center in Riverdale overlooking the Hudson River. It is listed on the National Registry of Historic Places, and the main entrance is located at 675 West 252nd Street near Independence Avenue. The New Jersey Palisades are in the background in this Bill Twomey photograph.

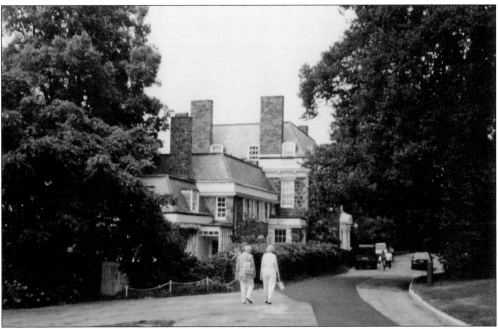

William Lewis Morris originally constructed the mansion at Wave Hill of gray stone in 1843. Wave Hill was enlarged and improved, and Theodore Roosevelt's family resided here in the summers of 1870 and 1871. Mark Twain called it home from 1901 to 1903, and Arturo Toscanini lived there from 1942 to 1945. The estate was deeded to the City of New York as a public park in 1960.

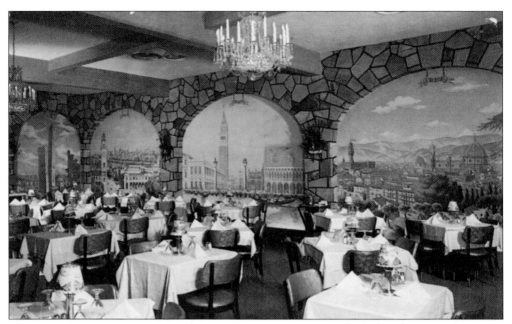

This is a 1950 interior view of the of the Stella D'oro restaurant, which closed in 1989, located at 5806 Broadway at West 238th Street. The restaurant featured Italian cuisine and included fresh desserts from the Stella D'oro Bakery next door. The bakery was founded in 1932 by Angela and Joseph Kresevich. The bakery was shut down in 2009, resulting in the loss of 134 jobs.

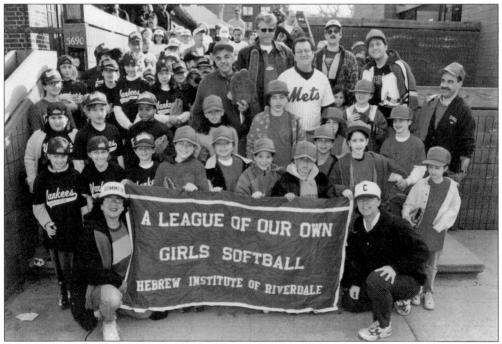

The Hebrew Institute of Riverdale is an orthodox synagogue located at 3700 Henry Hudson Parkway. The institute is affectionately called the *bayit*, which means a welcoming place of refuge, a place one can call home. This photograph shows girls proudly displaying a banner bearing the words, "A League Of Our Own, Girls Softball."

This attractive residence was the boyhood home of Pres. John F. Kennedy and is located at the corner of West 252nd Street and Bingham Road (Independence Avenue). John F. Kennedy lived here from September 26, 1927, to June 1929. During this time, he attended the Riverdale Country School, where he completed the fifth through seventh grades. Kennedy's sister, Kathleen, and brothers Robert and Joseph P. Jr. also attended Riverdale Country School.

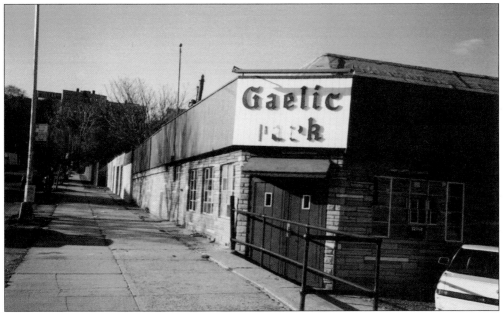

Gaelic Park was established in 1928 on West 204th Street just west of Broadway. It had been known as Innisfail Park until the 1950s and was popular for Irish football and hurling matches. Many dances and concerts were also held there, and Manhattan College leased the park in 1991. The college also uses the park for their lacrosse, soccer, and softball teams, but hurling and Irish football still attracts big crowds on Sundays.

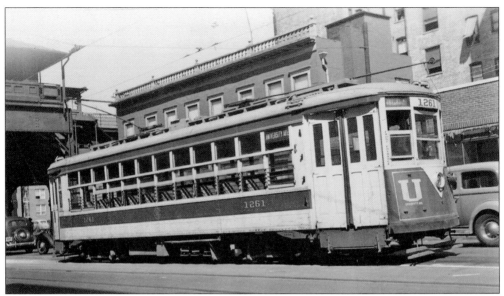

Streetcar number 1261 (Brill, 1926) was acquired as a secondhand car from Sunbury, Pennsylvania. It is on the U-University Avenue line at the 238th Street and Broadway terminus of the line, and the photograph was taken in September 1941. (Courtesy of Bill Armstrong.)

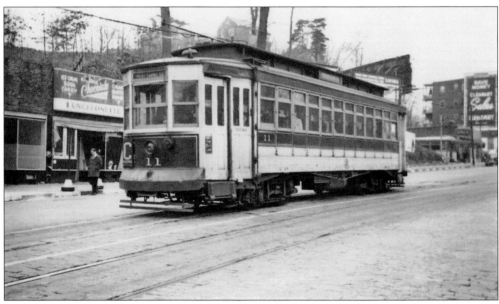

This photograph evokes memories of the cold winter months when one notices how the passengers are dressed and, no doubt, enjoying the heat from the resistor coils beneath the seats. It shows convertible streetcar number 11 (Brill, 1909) on the C-Bronx and Van Cortlandt Parks line just leaving its terminus at Broadway and 262nd Street as it heads for its eastern terminus at West Farms. (Courtesy of Bill Armstrong.)

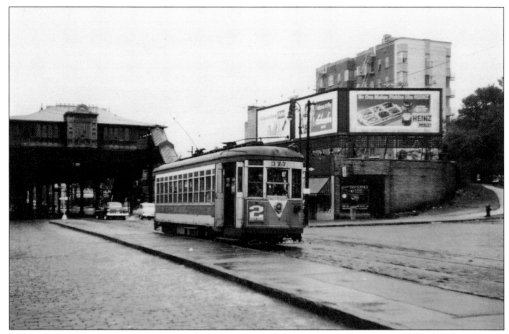

This June 1952 photograph captures Third Avenue Rail System Trolley number 377 heading north from the West 242nd Street Subway terminus on Broadway on its way to Yonkers. The signage advertises the popular Schaffer beer and Heinz television dinners. Trolley service to and from Yonkers ended in November 1952.

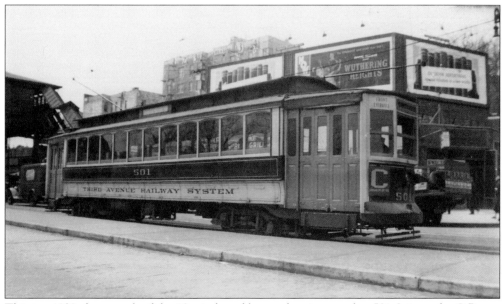

This is a 1939 photograph of the 12-windowed boxcar bearing number 501. It is on the C-Bronx and Van Cortlandt Parks line at Broadway and 242nd Street. (Courtesy of Bill Armstrong.)

This is a view of the entrance to the chapel of the John Cardinal O'Connor Clergy Residence located at 5655 Arlington Avenue next door to the Riverdale YMHA. In 1902, it was the Monastery of the Visitation for cloistered nuns, and from 1980 to 2001, it was the St. John Neumann Residence and Seminary College. Thirty retired priests of the Archdiocese of New York now reside here.

The Cardinal Spellman Retreat House is located at 5801 Palisade Avenue in Riverdale and overlooks the Hudson River. This is the chapel of the complex, which includes approximately 150 private retreat rooms and is run by the Passionist priests and brothers. Ground was broken for the 14-acre complex in 1966, and it opened for retreats in January 1967. A provincial meeting was held in May 2010, and the retreat house closed at the end of that year.

The Riverdale Presbyterian Church was organized on June 24, 1863. It was constructed of locally quarried stone in English Gothic style and was dedicated on October 11, 1863. Located at 4765 Henry Hudson Parkway, it was designed by James Renwick, and the sanctuary and Duff House of the church were declared New York City landmarks in 1963.

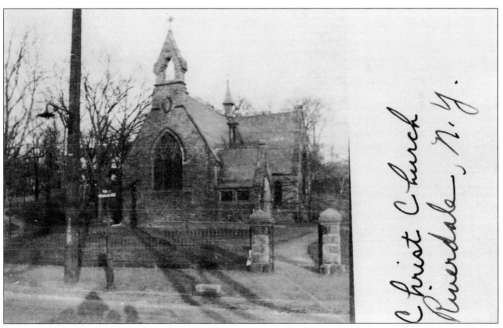

New York City landmark Christ Episcopal Church, located at 5030 Henry Hudson Parkway at 252nd Street, was designed by Richard M. Upjohn. It was constructed in 1866 in Victorian Gothic style. New York Yankee great Lou Gehrig died at his home at 5204 Delafield Avenue in the Fieldston section of Riverdale, and his funeral was held at Christ Episcopal Church.

This is a 1907 view of the Booker T. Washington Field at the Colored Orphan Asylum located just south of the College of Mount St. Vincent on the Hudson River shoreline. The asylum at Fifth Avenue and Forty-fourth Street was burned down during the Draft Riots of 1863, and it moved to Riverdale in 1907. The 19-acre campus was acquired by the Hebrew Home at Riverdale after the orphanage closed in 1946.

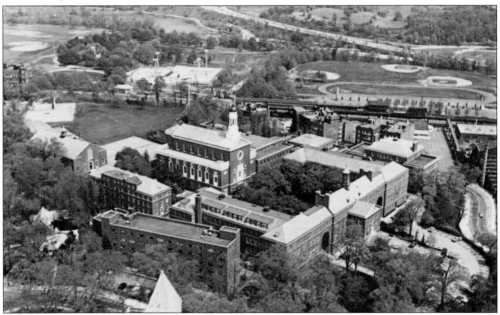

Manhattan College, run by the Christian Brothers, was called the Academy of the Holy Infancy when established on Canal Street in 1849. The school moved to Manhattanville in 1853 and became Manhattan College when it received its Regents Charter in 1863. Their current site in the Bronx west of Van Cortlandt Park was located in 1903. It is currently one of the leading engineering schools in the country.

Lois A. Bangs and Mary B. Whiton established their finishing school for girls in 1905 in the Goodridge Mansion, and the Horace Mann School leased it in 1918. Frederick Goodridge erected the mansion before the Civil War at West 250th Street and East Henry Hudson Parkway. In 1959, the Conservative Synagogue of Riverdale purchased the property and held services there in the new synagogue designed by architect Percival Goodman.

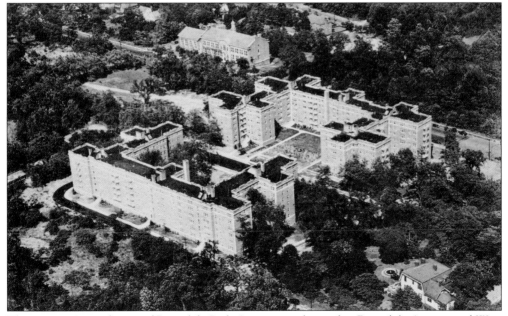

This is a 1940 aerial view of Riverdale Park Apartments located at Riverdale Avenue and West 254th Street. Riverdale Park is now a cooperative of two six-story buildings containing 270 apartments. The 1926 Dwight James Baum–designed Robert J. Christian School (P.S. 81), at 5550 Riverdale Avenue at West 254th Street, is viewed in the upper center of this image.

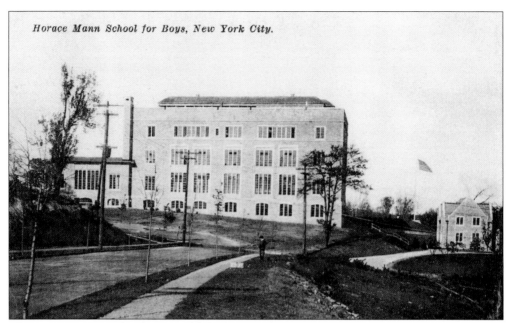

Horace Mann School for Boys, New York City.

The Horace Mann School was established in Manhattan in 1887 by Nicholas Murray Butler. It ceased to be coeducational, and the boy's school became independent and moved to the Bronx in 1912. The last all-male class graduated in 1976 after the school became coeducational in 1973. The 18-acre campus is located at 231 West 246th Street. The school is noted for its large number of Pulitzer Prize-winning graduates.

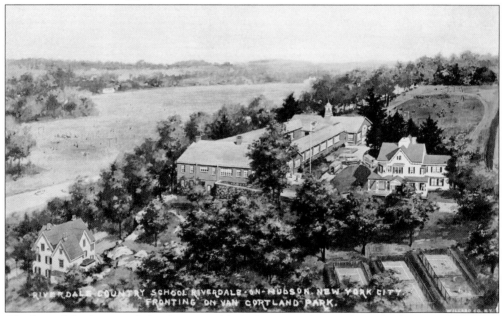

The Riverdale Country School was established in 1907 by Frank S. Hackett on the former Griswald Estate. He eventually was able to purchase the nearby Gethin Estate, and Burt Fenner designed a new school building on the 12-acre site, the cornerstone of which was laid in 1917. The school continued to grow both in numbers and prestige. It is located at 5250 Fieldston Road in Riverdale.

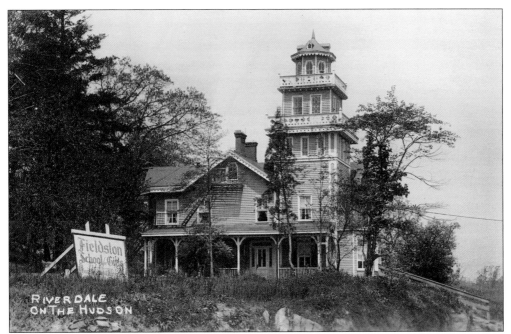

This is a 1926 postcard that was used to advertise the Fieldston School for Girls, located at West 253rd Street and Fieldston Road. The building, which is located just north of Post Road, has been altered over the years and no longer features the tower and widows walk.

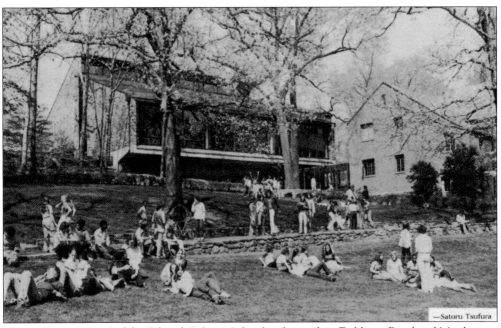

The Fieldston School of the Ethical Culture Schools is located on Fieldston Road and Manhattan College Parkway. This 1960s postcard depicts the diverse and socially aware students enjoying a spring day on the green of their bucolic tree-lined high school campus. Many noted artists, writers, journalists, and musicians were Fieldston graduates. Actress Louise Lasser of the television show "Mary Hartman, Mary Hartman" went to Fieldston.

BEN RILEY'S ARROWHEAD INN, 246TH ST. AND RIVERDALE AVENUE, NEW YORK CITY

Ben Riley's Arrowhead Inn was built on a 17-acre site and opened in April 1924 at 246th Street and Riverdale Avenue. It was designed by Dwight J. Baum. Ben Riley's establishment closed in 1941 and was transformed for services by Rabbi Charles E. Shulman of the Riverdale Temple from 1947 to October 1952. The Briar Oak housing complex was then built on the site, and a new Riverdale Temple was dedicated on September 17, 1954.

PAUL'S RESTAURANT
Mosholu Ave. & Broadway at 258th St., N. Y.

MAIN DINING ROOM

This is a 1940 double postcard view of Paul's Restaurant located at the corner of Broadway and Mosholu Avenue. The former hotel and carriage stop has been replaced by a nine-story condominium.

Charles H. Buck captured this winter scene at Engine Company 52 in 1907. Outrage due to loss of lives and injuries from an 1882 train accident and fire at Spuyten Duyvil led to the construction of the old wooden firehouse by 1884. Engine 52 and Ladder 52 have valiantly served the greater Riverdale community for over 125 years.

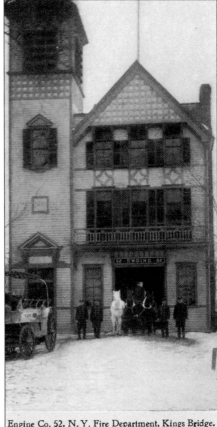

Engine Co. 52, N. Y. Fire Department, Kings Bridge.
CHAS. H. BUCK, KINGS BRIDGE, N. Y.

This is a 1907 multiple view postcard of Elmhurst, the home of Giovanni P. Morosini, and the east and west gate entrances. By 1887, Morosini was a partner with financier Jay Gould and acquired the 17-acre estate located west of Riverdale Avenue at West 254th Street. Morosini passed away on September 15, 1908, and is buried in the Oak Hill section of Woodlawn Cemetery. The property remained in the family until abandoned in 1932.

Elmhurst Residence of Mr. G. P. Morosini, Riverdale-on-Hudson, N. Y.

CHAS. H. BUCK

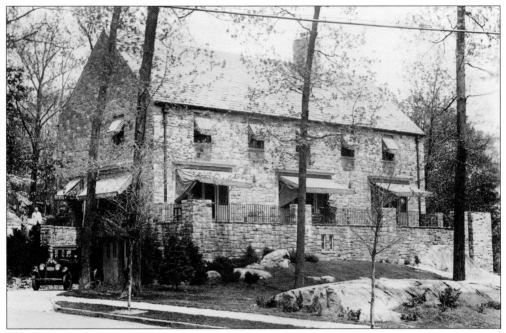

This is a 1924 view of the Livingston Avenue home in Fieldston of tycoon Edwin Wasser. Clarence S. Stein was the architect. The Fieldston Property Owners Association manages the private streets of the 257 homes in this historic landmark district, bounded by the Henry Hudson Parkway, West 253rd Street, and Manhattan College Parkway.

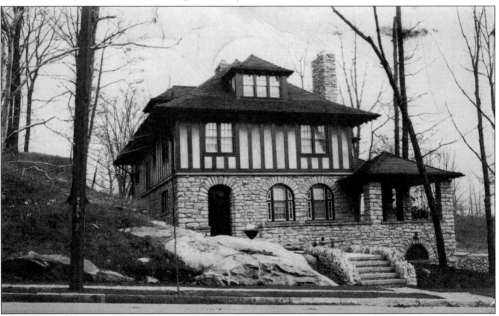

On December 24, 1912, Mr. and Mrs. Frederic Camp mailed this postcard of their home and invited their Manhattan friends up to Fieldston. Their home, designed by architect Nathaniel Vikers, is located on Waldo Avenue. Around 1910, the Delafield Estate developed part of their property to ensure that each lot would conform to the natural landscape and not the city grid pattern. The resulting community was called Fieldston.

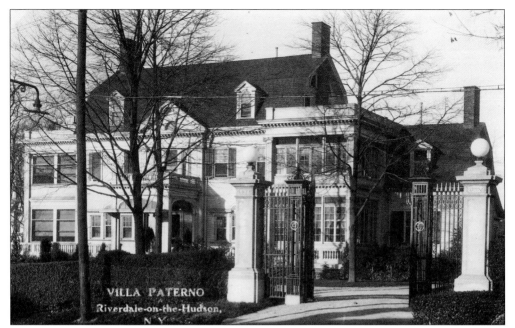

In 1920, Manhattan builder Joseph Paterno and his wife purchased the home of Judge Nash Rockubod at West 252nd Street and Blackstone Avenue for $100,000. The house and gate pillars are still standing. They also acquired the two adjoining acres from the Samuel D. Babcock estate. Mr. Paterno died in 1939 and was entombed in the Paterno Mausoleum at Woodlawn Cemetery.

This is a 1930 view of psychiatrist Dr. Henry William Lloyd's residence at West Hill Sanatorium, which was established in 1908. The 10-acre property at West 252nd Street and Fieldston Road was sold to Manhattan College after Dr. Lloyd's death in 1963 and then sold to the Riverdale Country School.

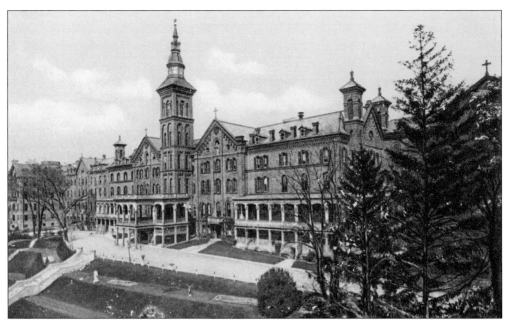

This is a 1910 view of the main building at the College of Mount St. Vincent, which is located on a 50-acre campus west of Riverdale Avenue at West 263rd Street. The property was purchased from Edwin Forrest in 1857, and architect Henry Engelbert completed the main building in 1859. The main building contains administrative offices, classrooms, and a large chapel.

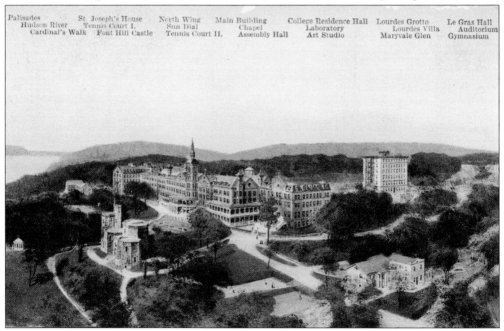

Palisades	St. Joseph's House	North Wing	Main Building	College Residence Hall	Lourdes Grotto	Le Gras Hall
Hudson River	Tennis Court I.	Sun Dial	Chapel	Laboratory	Lourdes Villa	Auditorium
Cardinal's Walk	Font Hill Castle	Tennis Court II.	Assembly Hall	Art Studio	Maryvale Glen	Gymnasium

This is a 1910 panoramic view of the College of Mount St. Vincent located at Riverdale Avenue on Hudson. Fonthill Castle in the left foreground is a replica of Fonthill Abbey in England and was built in 1852 by Shakespearean actor Edwin Forrest (1806–1872) for his wife, Catherine. The college campus was the set location for John Patrick Shanley's 2008 Academy Award nominated movie *Doubt*.

Six

VAN CORTLANDT PARK

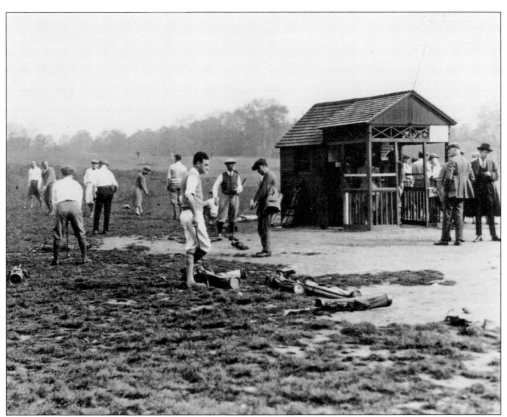

This is an interesting photograph of the golf starter house at the first hole in Van Cortlandt Park. The Van Cortlandt Park Golf Course opened in 1895 and is the oldest public course in the country. A lady golfer, just left of center, is practicing her swing and is fashionably dressed is this c. 1920 photograph. In 1895, the course had nine holes, with a 700-yard ninth. Now it is an 18-hole course, and the new hole is only 619 yards to the flag.

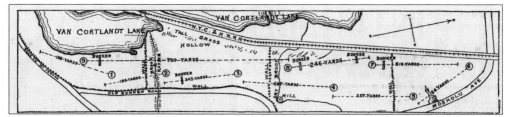

This is a map of the Van Cortlandt Park golf course, which comprised 5,121 yards when it opened in 1895. The first scholastic golf tournament in New York was held on Election Day 1896 by 15 students of the Berkeley School of New York City. It was won by George Stuart Studwell, with a score of 123. The best record for the 700-yard ninth hole is seven strokes.

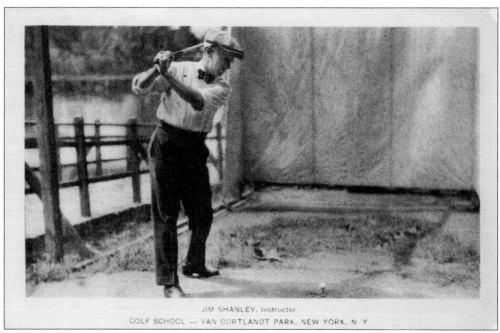

In 1905, Jim Shanley of the Bronx competed in a Van Cortlandt open golf championship representing the Van Cortlandt club. During the 1920s, when this postcard was published, Jim Shanley was an instructor at the golf school and fabricated many of the golf clubs that were marked with his name. Shanley and his family lived on Bailey Avenue, a short walk to the golf course.

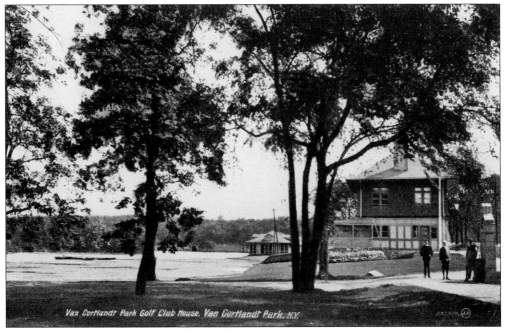

Van Cortlandt Park Golf Club House, Van Cortlandt Park, N.Y.

The lake, boathouse, and golf club house at Van Cortlandt Park is the subject of this 1908 postcard view. In the foreground, gentlemen are standing next to the Algernon Sydney Sullivan (1826–1887) monument that honors the noted jurist. Moe, Larry, and Curly of the comedy team the Three Stooges maintained golf lockers at the clubhouse.

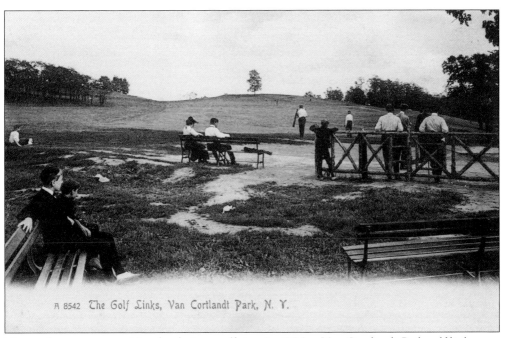

A 8542 The Golf Links, Van Cortlandt Park, N. Y.

Men and woman are waiting for their tee-off time in 1906 at Van Cortlandt Park golf links, as a few potential caddies look on. The nine-hole course was the first public course in the United States when it opened in 1895, and the expanded 18-hole course is still one of New York City's finest.

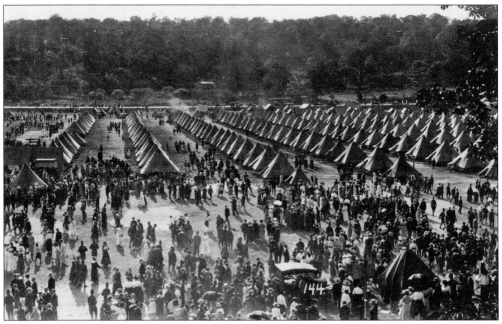

On May 13, 1911, a throng of 20,000 people attended the sham battles and horse jumping performed by the 12th Regiment of the National Guard at the parade grounds of Van Cortlandt Park. A runaway horse led to panic, and the quick action of the five policemen and the Boy Scouts from Riverdale quelled the disturbance and limited injuries.

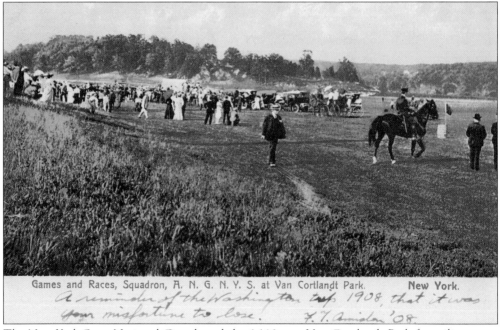

Games and Races, Squadron, A. N. G. N. Y. S. at Van Cortlandt Park. New York.

The New York State National Guard used the 1,146-acre Van Cortlandt Park for military war games and recreation. The guard occupied the Kingsbridge Armory, which was completed in 1917, and would frequently march to Van Cortlandt Park. The Van Cortlandt parade ground in this 1908 image was used for games and races.

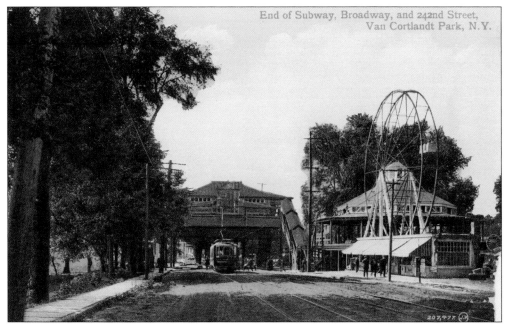

The elevated subway line of the Interborough Rapid Transit Company (IRT), the Broadway Seventh Avenue line, would reach the final stop at Van Cortlandt Park at West 242nd Street and Broadway in 1908. Around 1917, passengers from Manhattan could visit a small amusement park with a Ferris wheel and a carousel pavilion that included a band shell on top. The 1,146-acre Van Cortlandt Park is to the east. Trolley service to Yonkers ended in November 1952.

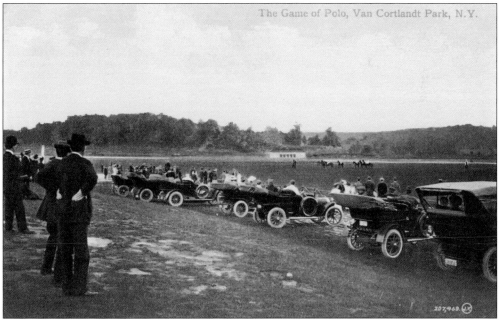

The Game of Polo, Van Cortlandt Park, N.Y.

A game of polo at Van Cortland Park is the subject of this 1911 postcard. The Westchester Polo Club was organized at the Jerome Park Race Track in 1876. The Van Cortlandt Park parade grounds were perfectly suited for the sport that required a vast open and flat area. The view is to the north with Vault Hill, the burial place of the Van Cortlandt family, in the background.

Tennis was a mixed doubles sport on this 1908 sunny day at Van Cortlandt Park. The Van Cortlandt Mansion facing south was built in 1748–1749 and is the oldest building in the Bronx. Tennis is being played on the front lawn, while today the tennis courts are on the east side of the mansion. Cricket is also a popular sport played on the north side parade grounds and fields.

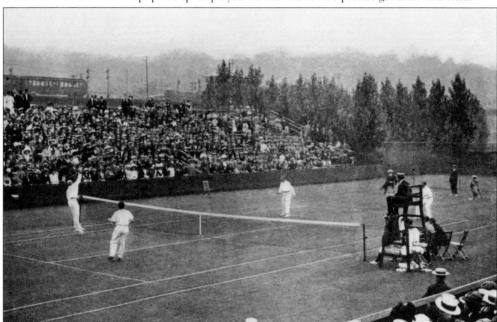

This is a September 11, 1911, photograph of the international tennis match at the West Side Lawn Tennis Club that moved to West 238th Street and Broadway in 1907. Thomas Bundy and Raymond Little led the Americans, and Charles Dixson and A.E. Beamish were on the British doubles team, playing for the Dwight F. Davis International Cup. The West 238th Street subway stop is visible in the center of this image.

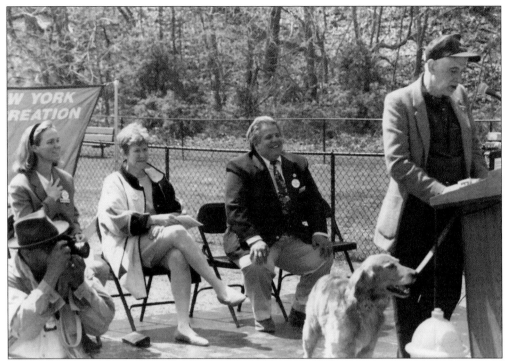

Parks commissioner Henry Stern officially opened Canine Court at Van Cortlandt Park on April 14, 1998. Boomer the wonder dog is at the podium with the commissioner. Seated from left to right are Susan Morgenthau, Felicity Nitz, and dog trainer Bashkim Dibia.

ON THE LAKE, VAN CORTLANDT PARK, N. Y. Pub. for Shipman Stationery Co.

The lake at Van Cortlandt Park was formed centuries ago by the overflow of Tibbetts Brook and has long been a favorite site for boaters and canoeists. The cold winter months have drawn ice skaters to the lake for well over a century. The Van Cortlandt Park Inn can be seen in the far left background while the right background shows the clubhouse of the golf course. This scene was captured on a 1920s postcard.

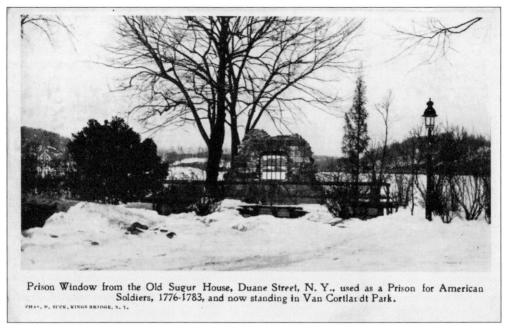

Prison Window from the Old Sugar House, Duane Street, N. Y., used as a Prison for American Soldiers, 1776-1783, and now standing in Van Cortlandt Park.

CHAS. P. BUCK, KINGS BRIDGE, N. Y.

This window section from the Rhinelander Sugar House was salvaged when the mill was razed around 1892 and was relocated to the rear of the Van Cortlandt Mansion in 1902. The Sugar House was built by William Rhinelander in 1763 and was located at Rose and Duane Streets in lower Manhattan. Many historians believe that it was used by the British to house prisoners during the Revolutionary War.

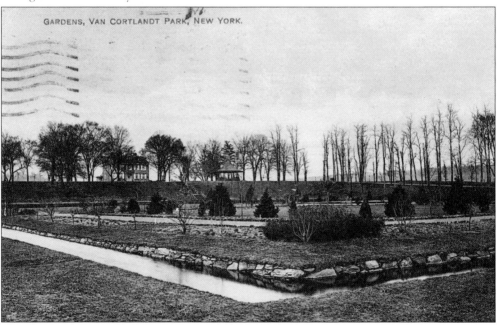

GARDENS, VAN CORTLANDT PARK, NEW YORK.

This is a 1910 view looking north from the Dutch Gardens and mansion at Van Cortlandt Park. The sunken gardens were reached from steps leading down from the mansion and were surrounded by a moat fed from the lake. A small garden remains today, along with a 164-foot outdoor pool that opened in 1970.

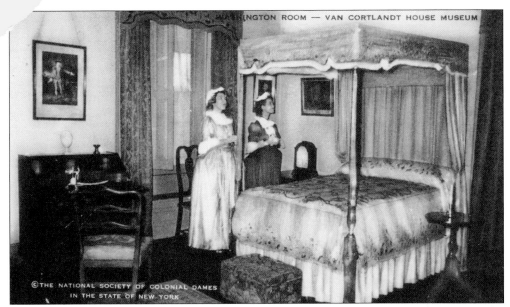

©THE NATIONAL SOCIETY OF COLONIAL DAMES
IN THE STATE OF NEW YORK

This is a 1930s view of the Washington Room of the Van Cortlandt Mansion and Museum. The postcard also identifies the National Society of Colonial Dames in New York, the current caretaker and guide of the 1748 home. Gen. George Washington stayed at the house in 1776, 1781, and also on November 18, 1783, when he prepared to take possession of New York City from the British at the end of the Revolutionary War.

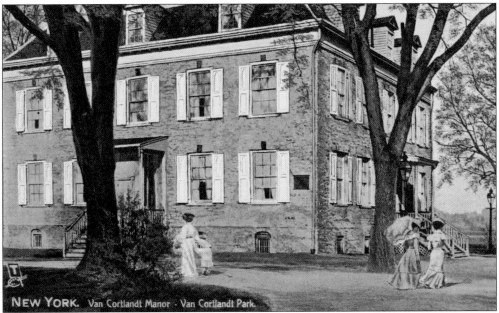

NEW YORK. Van Cortlandt Manor - Van Cortlandt Park.

Construction of the Van Cortlandt Mansion began in 1748 and is credited to Frederick Van Cortlandt, who inherited the property from his father, Jacobus. The mansion was used for a short time as Gen. George Washington's headquarters during the Revolutionary War. The Georgian-style mansion and grounds was given to the City of New York by the Van Cortlandt family in 1889 for use as a public park. It is a National Historic Landmark under the care of the National Society of Colonial Dames.

DISCOVER THOUSANDS OF LOCAL HISTORY BOOKS FEATURING MILLIONS OF VINTAGE IMAGES

Arcadia Publishing, the leading local history publisher in the United States, is committed to making history accessible and meaningful through publishing books that celebrate and preserve the heritage of America's people and places.

Find more books like this at
www.arcadiapublishing.com

Search for your hometown history, your old stomping grounds, and even your favorite sports team.

Consistent with our mission to preserve history on a local level, this book was printed in South Carolina on American-made paper and manufactured entirely in the United States. Products carrying the accredited Forest Stewardship Council (FSC) label are printed on 100 percent FSC-certified paper.

MADE IN THE USA